ROMANTIC OIL PAINTING
MADE EASY

by Robert Hagan

international
artist

International Artist Publishing, Inc
2775 Old Highway 40
P.O. Box 1450
Verdi, Nevada 89439
Website: www.internationalartist.com

Concept and Design by Vincent Miller
Edited by Terri Dodd
Photography by Robert Hagan
Typeset by Elizabeth Azel

Printed in Hong Kong

ISBN 1-929834-29-2

First published 1995
Reprinted 1996
Reprinted 2003 (paperback)

Distributed to the trade and art markets
in North America by:
North Light Books,
an imprint of F&W Publications, Inc
4700 East Galbraith Road
Cincinnati, OH 45236
(800) 289-0963

Additional books by Robert Hagan
Images of Australia 1994

Acknowledgments

I have learnt by trial and error that you must be immune to negativity when you decide to break with an established profession as I did when I decided to give up teaching to become an artist. If you are dedicated, patient and extremely hard-working, you have a good chance of becoming a participating artist. If you are imaginative, creative, resourceful, and you possess a degree of business acumen, you will cut a path of greater attention.

I will avoid talking about those individuals and institutions who sought to discourage and negate my efforts as a waste of time, and focus on the individuals and galleries that have supported me and remain my best associates and friends. Time tested over 20 years!

In terms of artists, I am indebted to a couple of good blokes with whom I have painted and shared the odd ale: the late Joe Thomas, with whom I shared the experiences of *plein air* painting; Rex Newell, with whom inspiration and self-taught notions about painting were swapped, and Ron van Gennip who was there to assist in my many endeavours, as well as be an astute sounding board for my various theories. A newer friend, but a great contributor to my merchandising approach, was the late Doug Firth.

Then I would like to acknowledge those who believe in me and my value to posterity: I kick off with my good mate, Keith Bolling, who provided me with the family caravan, as well as $100 a week, "just to paint". That was 20 years ago, and he remains a top bloke. The late Terry Blake, without whose association it was likely nothing would ever have happened. I can say the same for Alan Veitch, Jim Oram, C.J. McKenzie, Sean Flannery and Col Mackay.

There are those who have simply supported the essence of my art: former Premier of New South Wales Barrie Unsworth; former Prime Minister of Australia Bob Hawke; media mogul John Singleton; co-horse owner Stan Dumbrell; and to mix it up a bit, Olympic Gold Medallist Dawn Fraser.

Then there are my friends of a kind: John Woodley, Trevor Lind, Clarrie Conners, Bill Herd, Robert Gear and Stephen Rockliffe, without whose assistance most of my efforts would be in vain.

No artist can survive without the support and belief of a gallery. To this end I thank my oldest associate, Noella Byrne, of Sydney; John Thompson, of England, and Bill Cahill of the USA. Without these people I would not have come to the notice of the public.

Lastly, my thanks go to Vincent Miller and Terri Dodd and the other good folk at "Australian Artist", for their professionalism, expertise and encouragement to do this book, which I dedicate to my three children, Michelle, Joe and Graeme.

Contents

INTRODUCTION

"I believe every painting should tell a story..."

I thoroughly enjoyed creating all the paintings demonstrated in this book, mainly because they evoke memories of my own childhood. They tell quaint romantic stories — either of children playing cricket, catching frogs, fishing, or sitting quietly on the banks of a stream. I believe every painting should tell a story. I see activities in every scene, in every landscape, in every little glen. Wherever you go there is activity: birds, kids flying kites, girls walking and talking and discovering what life is all about. In my case, I relate to the picture of a little boy with a fishing pole in his hand and hope in his heart.

Many people become blind to what's going on around them because life is full of commonplace things, but to me it's important to record these everyday things. That's my role as an artist — to identify the stories in life and project them in an entertaining way.

There is stress all around us and I believe that the job of the artist is to present the opposite of that.

Every painting should be an enriching experience to the viewer in some way. I hope the "painted stories" in this book will strike a chord in you and, perhaps, open your eyes to the many possibilities in the world around you.

MATERIALS
A Few Simple Tools Do The Job

These few tools are all I use:
1" Pure Bristle Brush
No 2 and No 4 Flat Bristle
Painting Knife
Short handle long hair Sable Brush
Cotton duck stretched canvas

My Basic Palette

This is what I call "Hagan's Basic Palette" — all of the paintings in this book were created using these colours.

Naples Yellow	**Indian Red**
Cadmium Yellow Deep	**Cobalt Blue**
Yellow Ochre	**Light Blue**
Raw Sienna	**Cerulean Blue**
Light Red	**Ultramarine Blue**
Cadmium Red	**Windsor Blue**
Rose Madder	**Titanium White Soft**
Alizarin Crimson	

The Mother Colours

The two most important colours I use are Light Red and Cobalt Blue. I call them the "mother colours" and you will notice they are always in my palette no matter what the subject. I highly recommend them because they behave like each other when mixed with white. Mixed in their pure form they make a good dark. Mixed together with white they make an excellent utility grey. Where shadows occur I'll use this grey to "break back" or take the colour edge off the true exposed colour. So when I talk about getting the shadow value I'll be suggesting you bring these colours into play.

Important ingredients of "Hagan's Palette" are what I call my "kick-along colours" — these are colours that have more local importance, like Cadmium Red, Cadmium Yellow, Permanent Rose and Australian Red Gold.

Painting a picture is like playing a game of chess — there is an infinite number of moves within a set system of rules. You can use an innovative way of approaching a checkmate, but it is still extremely important to be disciplined in your approach.

There are rules of colour, composition, of balance and harmony which have to be addressed to the best of your ability, and if they are not, you will probably end up with a second-rate painting.

My palette after four years!

"Painting a picture is like playing a game of chess — there is an infinite number of moves within a set system of rules."

SKETCHING AND PAINTING FIGURES

"Know what you are going to paint."

Before you paint a figure, an animal, a bird or an object you must go through the discipline of becoming familiar with its shape and characteristics. This may be onerous, but it is an important building block on which to structure a successful painting.

I remember one young man who asked me to teach him how to paint, and I stressed to him the importance of drawing.

I said, "I'll give you your first lesson on the type of commitment required in painting. Here's a photograph of a seagull, here's a sheet of canvas, here are three tubes of paint, plus white. I want you to paint that seagull one hundred times as it is. When you've done that, come back and see me."

About three months later he came back and I looked at his drawings. The first one looked a bit "shonky", but by about the fiftieth one you could see more of an understanding of the shape of the bird, the contrast elements, the little nuances of shade and colour under the wing and side of the bird. In other words, he now understood the ingredients of making that shape identifiably a seagull. I told him, "Well done".

He said, "Yes, but it took that blinking long that I never want to paint another seagull ever again!" I said, "If you don't want to paint a seagull again, give up painting, because that's the degree of commitment required in becoming a professional artist."

And that applies to every element of painting, whether it be a tree, grass, or more abstract things to do with harmony and balance. These things only come with time, so discipline must be accompanied by patience!

That is my basic homespun philosophy. It's a step-by-step process, and if I can give some advice it would be don't try to paint everything — just concentrate on one area. Become proficient and your skill will evolve as you come to grips with each problem and develop the kind of discipline necessary to take you from being a weekend artist to becoming a professional artist.

So initial sketches are essential! When you are accustomed to the shape and components of your subject you can then concentrate on getting the values and colours right.

The sketches you see throughout this book are working sketches. I always look to the outside line first and sort of imagine that the inside is all black, the duck on the left.
Then I isolate the light spots, as for the other duck. In the case of human figures I'll highlight skirts, hats, shirts, collars, bags, shoes, and so on.

The Inheritance Factor

An important point that needs to be brought into the equation in the demonstrations contained in this book is the idea of inherited colour.

Let me ask you a question — what is the colour of fleece on a sheep?

It is white/yellow, okay! But, what is the colour under the sheep if it is standing in a field of purple flowers? The not-so-obvious answer is that it "inherits" the colour, so it becomes a white/yellow tinged with purple.

If there is a blue sky up above, what is the "click" highlight on the leaves of the trees beneath? Again, this inheritance factor comes into play. The light contains a hint of blue (along with the yellow from the sun).

Every part of a painting inherits colour from other parts of the painting. I call this "bleeding", and you will see this over and over again as we progress through the demonstrations. It is this kind of attention to detail that will lift your paintings from the ordinary — they will just look RIGHT.

INFORMATION GATHERING WITH PHOTOGRAPHS

"Using ingredients from reference photographs can help you make better paintings!"

In this book you'll learn the professional way to use reference photographs. Notice I didn't use the words "copy from photographs". What I'll show you is how to select real life ingredients, change them and combine them to make a scene that tells a story of your own invention. Because the ingredients are real, the results will be real.

Good reference photographs are essential. Invest in a good camera and take it with you everywhere. I recommend 200 ASA film printed on the largest size paper you can get away with at a good price. I often blow up really good ones to 10" x 8". I must have hundreds of photographs in my collection, all sorted into categories: kids, horses, cattle, dogs, trees, female figures and so on, some of them I use over and again because to me they represent moments of truth. When you are studying human nature nothing comes close to the candid photograph. When you look at some of the "Johnny on-the-spot" reference photos that I used in this book I think you'll agree that incorporating them gives my paintings the ring of truth in body posture, clothing and attitude.

Something that people not used to working with photographs often don't realise is that you can manipulate the photograph to give you a sense of scale and perspective.

For instance, if you hold up a figure reference photograph at full arm's length away from you while you are standing beside your canvas, and then look at the photo. you will have a good idea what the figure looks like at a distance. Bend your arm and compare the photograph to the canvas and the figure looks different.

Then hold the photograph close to your face and you will see a new vision. Don't be afraid to milk photographs for all they are worth, there is nothing wrong at all with using them, and they are perfect for studying light and shade effects.

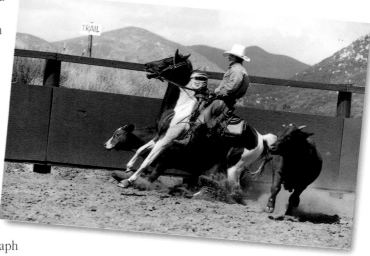

THE NUTS AND BOLTS OF MAKING A PAINTING

A perfect starting point for learning how to put a painting together is to examine the everyday beach scene. This condition of nature provides an initial arrangement of a few elements from which the mechanics of composition, balance, colour, and value in particular, can be understood. Expanded upon, such an understanding can and should lead to good paintings of a broad nature.

So, go down to the beach and look out across the sea to the horizon. Tilt your head back and look at the sky. See the condition of the sky, the clouds, their highlights and their shadows, and the colour between, and how it changes from the sky above you to the horizon. Then look down from the horizon to your feet and see the sand in its rich yellow form broken with pebbles and shells, and so on. Lift your eyes and see waves breaking and rolling in, and further out study the apparent blending of the sea with the sky at the horizon. You are looking at fairly raw expressions of nature in colour. Blue sky, yellow-white clouds and yellow-brown sand.

One mile out to sea we see a yacht with a red sail, or at least it seems red, but because of the "salt air" we can't be really certain just how red it is, but then again, we know it's red because we witnessed the boat leaving the dock an hour ago!

We know that the colour of objects softens as the distance increases ... colour and intensity seem to bleed out. As we look around, the miracle that is our eye mechanism tries to make allowance for these altered conditions. It knows there is another force at play.

Let's try to untangle these various conditions and nail down the mechanics that will help us to paint better pictures. Let us start with how this "force" or atmosphere and distance effect colour and value.

An Exercise in Understanding Colour Value, Tone and Aerial Perspective

The Mother Colours

Start by laying out just three colours: Cobalt Blue, Light Red and Yellow Ochre. A tube of Titanium White Soft joins in. This does not constitute a colour. Now the reason I use these colours is simple (although it took me five years to work out). The blue and the red are very similar in their behaviour: they are about equal in their strength (or chroma) and that's handy because when white is added to them they both "break back" at about the same rate. Together in their tube state they make a good dark. Individually, with white, they make a pretty vibrant light red or blue. Mixed together with white added they make a thoroughly believable grey, as you will see here.

Throughout this book I refer to Cobalt Blue and Light Red as the "mother colours". Every mix comes from, or has part of these colours.

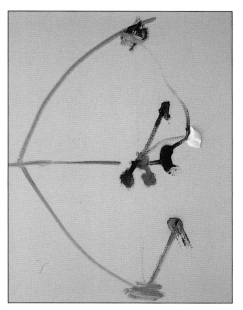

By adding a little more of the red than the blue with the white we can get a nice warm (red) grey. Conversely, with more of the blue than red, we create a totally handy cool (blue) grey.

Observation tells me that the area of least definition and greatest mystery is the horizon, and that as we look to things closer to us clarity and colour improves. To represent this effect I have drawn a curve that starts out beneath us (where the sand would be) and sweeps towards the horizon (where the horizontal line intersects), then sweeps back towards us so that it finishes over our heads.

The distance from the horizon to our imaginary vertical line that joins the ends of the two perspective arcs and intersects the horizontal line in the middle, is about six miles (the viewing distance over the ocean, allowing for the curvature of the earth). We are positioned at some point on that vertical line. Commonsense has it that any dimming of clarity and dilution of colour is due to the effect of looking through miles of water particles (or salt spray) as well as pollution. Either way, the atmosphere confuses the clarity of colour, and distance amplifies this distortion. Here we see the "bluest" sky and the "yellowest" sand.

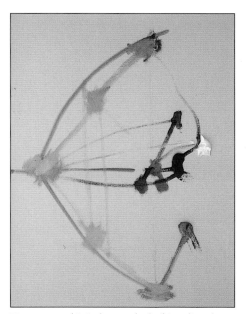

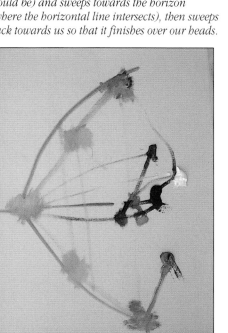

You can see this is the case by looking directly overhead. The blue of the sky is clearest. The clouds that break the sky directly overhead are the whitest and cleanest. The further away (or further along the curve to the horizon) the more blurred or greyed out they become. Their shape becomes less defined. When we look directly below us we see the rich yellow sand colour. There is less

interference from the atmosphere since it's only a few feet away! The horizon is the zone of greatest mystery, the area of least definition, the region of most greys and diffusion of colour. Between the horizon and where we stand, colour is diffused directly in relation to the distance. We also begin to notice yellow from the sand reflected in the sky, and grey from the clouds picked up in the sand.

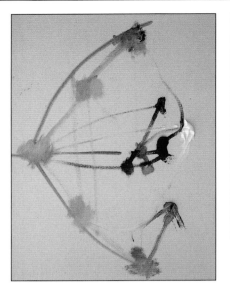

It must be remembered that each position on the perspective curve inherits the colour and value from the same position on the opposing perspective curve. There is an ongoing "bleeding" between counterpart positions.

Now let's move this theory into an actual painting.

We block in the three main anchor areas: sand, sky and horizon.

Each bridging area is easily mixed.

Just keep going back to the greys and by adding or not adding white you can move the colour and value closer or further away. If you understand these mechanics you will have no middle distance problems!

Now to the water zone! We all have this notion of blue water, especially on a fairly clear day, but it's also the case that in the distance water is not quite that blue. At a distance water reflects the condition above it just as it does close to us, and at a distance we know by sight that the sky simply doesn't retain that clean blue. There is an intermingling of colour. We look below the horizon at the sea. Start where there is most activity and contrast. With the waves in other words.

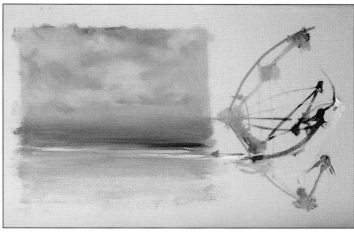

The blue drag line shows the starting point on the perspective arc. The value of this blue is reduced because it is some distance away from us. The water zone then extends to the horizon. It will take on a gradated increase in value as it approaches the horizon. The blue will become more grey and its value will increase. This is in fact what the eye sees.

So we bleed the water into the horizon.
To take the painting closer to reality, we must now work on going further with the sky.

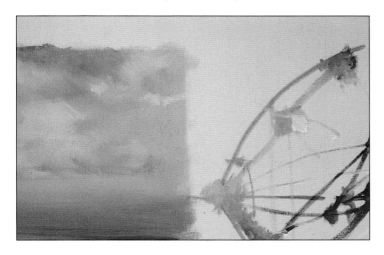

The middle distance in the sky is again a result of colour bleeding from the top of the perspective curve to the horizon! Artistically we must make the adjustment that nature sometimes fails to make. In dealing with such large areas it's imperative to switch the temperature of the greys from "cool" (more blue) to "warm" (more red) and vice-versa. Remember, you create excitement in the viewer's eye if a value shifts between warm and cool. We also need to create a bit of tension. Nature often does this with dramatic cloud formations, and we can recreate this, but for our purpose, clouds are looked at in terms of their composition and balance significance as well. I generally paint them three-quarters finished, and as the end of the painting approaches, return to complete final highlights and shadows.

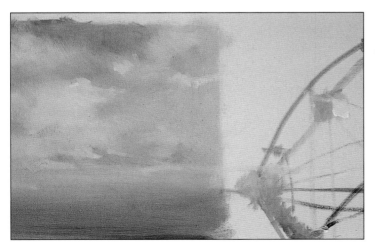

Back to this idea of interchange. Each arc inherits from the other. The undersides of distant clouds, for example, largely draw value and colour from the surface colour and value of the water directly below them. The highlight will be a stepped-up cream/grey taken from that particular distance along the upper curve or arc. This same approach applies to all parts of the sky. It's not guesswork!

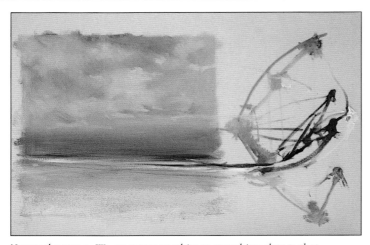

Now to the waves. We see waves as white or something close to that. Where these waves break is the area of biggest contrast in the scene. In this scene, and in the picture that follows we draw the deepest value colour into play as well as a near white.

The darks come from Light Red and Cobalt Blue — the "mother colours" for all the greys used throughout the painting, and these must be harmonious. In this instance, broken back a little according to the atmospheric conditions. Shifting from cool to warm throughout the breaking waves keeps the excitement high. (Other excitement colour can be used here — greens, yellows, and so on, but the mother colours must underpin the order).

Creating Order In a Painting

Once we have the groundrules established, it's time to examine another concept. The sharpest area, or point of contrast, is in the sand below and immediately around us. On a beach you can clearly see pebbles, stones, shell, sticks and the like. This is especially so at your feet.

Away from where we stand the shape and the intensity of colour of these objects is confused by the mist in the air, distance and so on. Now here's the key point — the colour we see at our feet, in all its intensity and variety, will be repeated in the sky directly above us because we are on the same vertical plane. So add a little bit of the sand colour to the blue above as well as to the clouds. By the way, it's pointless trying to go out and buy a "sand" or "sky" colour because these colours are "born" from the mother colours according to the equations we work with. The grey you get from the Light Red and Cobalt Blue is different from the grey that results from, say, mixing Indian Red and Ultramarine Blue. To buy a Paynes Grey to pop into the horizon because atmospheric interference tells us it is "grey" doesn't work. It's hit or miss and that's not good enough. Learn to mix your own colours and values right from the beginning.

The method as outlined works, and you can see that from a very simple starting point we have created a totally acceptable way of painting nature. Admittedly, we have applied this to one light condition and have not talked about how we adjust the equation to fit the morning or afternoon light or for say, a totally overcast day. Nor have we discussed how this works when applied to a landscape, and how that may work also under differing conditions. Suffice to say it does work. All my painting fundamentals to do with distance, colour and value are drawn from working along my "perspective curves".

Now to move on.

We have at this stage created a context for something and we have got this far by a logical process premised on observation of nature. A few questions though. How did we end up with a band of greatest attraction, or "command area", one third up from the bottom? What I have discovered, as has just about every artist who has ever lived, is that the eye is most comfortable with arrangements based on thirds. If you look at the leaves on the stems, and then the stems on the branches, then the branches on the trunk of a tree, you will discover they are ordered in thirds, and two-thirds

intervals. Nature has ordered itself in these proportions all around us. We seem to intuitively repeat this in design of clothes, cars, buildings or simply when arranging things around the house. The idea of putting things "off centre" is an everyday reference to this notion of nature. Whether we like it or not there is no doubt that there is a way of arranging things that "feels natural" and puts us at ease. So it is with painting. Order in painting is simply the artist responding and replicating the order of nature. On the basis of that, the area of greatest activity and contrast and authority in our painting should therefore be the breaking waves. And they are about a third up. Cloud impact should be about a third down and maybe a third across from the side. These decisions however, are contingent upon anything else that may be introduced into the painting as subject matter. If we ended the piece here though, we could finish off these "command spots" or authority areas with highlights and so on.

When we introduce a subject, whether it's as simple as a single seagull, the dynamics of balance and composition shift. On the adjacent page I have painted three alternatives to illustrate this point as well as introduce a few other thoughts.

The "whites" on the breakers accentuates the activity here.

For the wet sand look we go back to the grey on the perspective arc above that position on the lower arc that we are dealing with. By dragging this grey across the yellowed sand base we transform it into a reflective surface possessing both the look of sand and water. These are the ground rules, now we can go on to introducing a figure. (See sidebar opposite.)

Some Examples of How Moving Individual Elements Changes the Dynamics and Effectiveness of Your Painting

An arrangement that does not work!
This picture shows a seagull to the far right and about a third down from the top. This doesn't work because the bird is just too far off-centre, even though it provides a counterweight to the contrast in the breaking waves on the left. In addition to this, the bird is not appropriate because the eye of the viewer wants to follow it out of the picture because that's where it's headed!

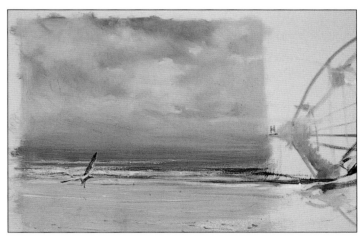

What about this second effort? This also fails. It is positioned a third up, but it just gets hopelessly lost in the waves. The bird may have been better positioned above the waves. If we use a subject we must maximise its impact, as well as ensure it does its job in terms of balance.

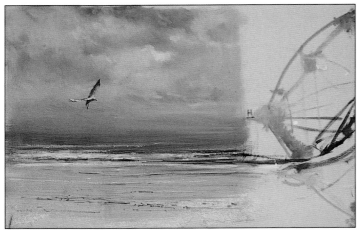

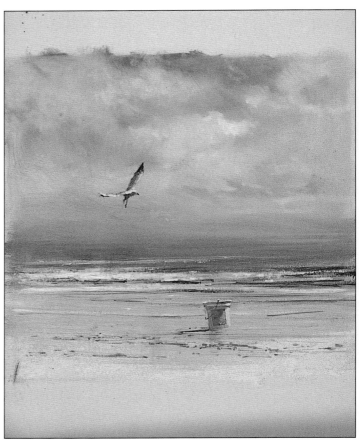

In the third attempt the seagull both offsets the strong impact of the waves to the left, and sits well in the sky. It sits below and to the left of the creamy cloud above. We have a sense of general equilibrium. Had I not had this third attempt at placing the seagull and simply given up in hopeless despair I would have gone back to the hanging creamy cloud a third down and to the right and worked it up with lights and darks to counter the weight of the waves to the left. A bird is better though because it brings life and action to a painting.

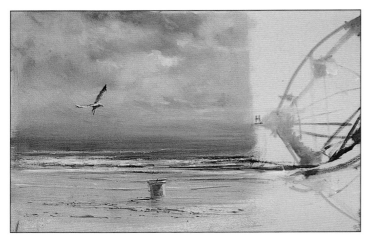

So what happens when we add multiple subjects? Is two better than one, or three better than two? Generally, your subconscious is happier with odd numbers. Rely on your instincts and remember how nature manifests itself. But back to our painting. I'm sort of reluctant to leave it as it is. Even if I put in another seagull, unless it's attacking the first or doing something that birds do, then there's not much of a story.

I go for a bucket on the beach off-centred to the right and below the breaking waves. Seagulls are always curious about such items on the beach as they may contain scraps of bait or the fisherman's sandwiches! Either way, we have a storyline. We have preserved our sense of equilibrium. With the main players in place it's now only a case of finishing off with dots, spots, lines and clicks.

Some More About Colour Value

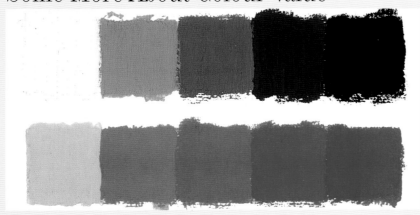

When we talk about colour value we mean pure colour, for instance Cobalt Blue, that varies in its intensity.

You will often hear artists referring to a colour value of "5" or "3". When they talk about this they mean a gradation of colour. The sky may be very blue overhead, and a much lighter (cooler) blue on the horizon.

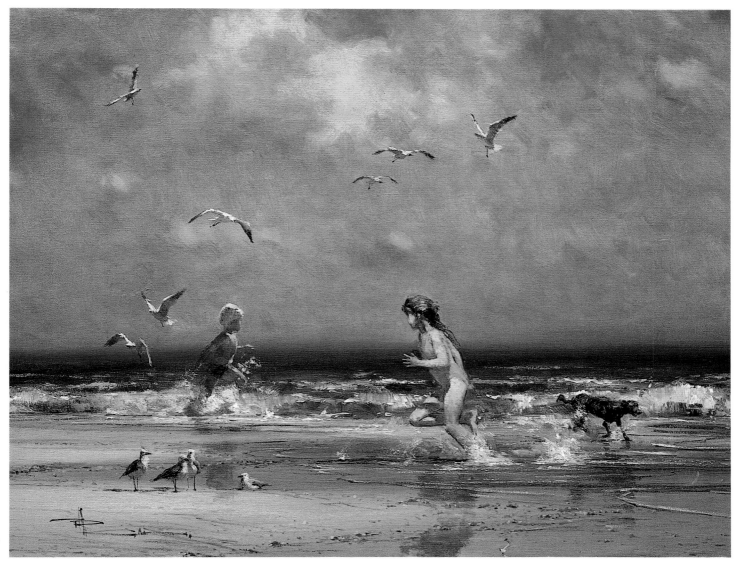

I consider this painting titled "Beach Splash" a good example of this approach to painting. Notice the blurred horizon, the reflections of the yellow sand in the cloud and the clouds in the water. Then observe the balance left and right and up and down created by the placement of the figures and birds. Feel the sense of action and excitement with the children chasing each other through the water with the family dog in hot pursuit.

As we stand at the windows of the painting with the lower perspective curve at our feet, notice the pebbles and shells. Isn't this how we observed the beach at the start?

Remember though, for a painting to be effective it should be spontaneous in execution, so that even when it has the look of being "loose" it's a look that comes from practice and close compliance with the rules.

When we talk about tone we refer to degrees of light. A black and white photograph is a perfect example of pure tone.

If you close your eyes until they are almost shut you will see the world in simplified tones.

Tone is independent of local colour. You can take any three colours, mix them into mud and still have tone.

When tone is affected by distance it becomes lighter, and this is what is known as aerial perspective.

Where the skill of the painter comes in is in dealing with all of this simultaneously and maintaining the balance of the painting's composition.

One reason the mother colours (light Red and Cobalt Blue) are particularly valuable is that they both have the same starting point on the value scale. They both start at "2", and therefore both "break back" at the same rate.

Study the masters of art: Vincent Van Gogh, for instance, was a magician with colour. Notice how he would balance a predominantly blue composition with a tiny touch of red or yellow — not placed at random, but done with a stroke of pure genius.

PLACEMENT THEORY

Command Areas, Lead-Ins and Lead-Outs

"Paintings should be viewer friendly. Here's how to do it!"

Don't demand too much of the eyes that view — entice and tantalise them! Let the viewer's eyes enter the painting, and then leave the painting. The force of the work is in what leads the eye and what it is lead to. This is the "command area" or "command post" or "spot" or whatever you may wish to call it! I call it the command! The word "focus" is a poor analogy since it implies singularity. Command imparts the sense of importance and delegation. The commander of an army unit is underpinned by others who support his or her purpose. So plan your paintings with a command area, and to make it successful, reinforce and support it a number of other lesser command aspects.

It is from the command areas that other areas are "keyed off" or given their relative importance. This importance comes from juggling contrast and/or colour. The greatest contrast and colour impact is always within the predominant command area.

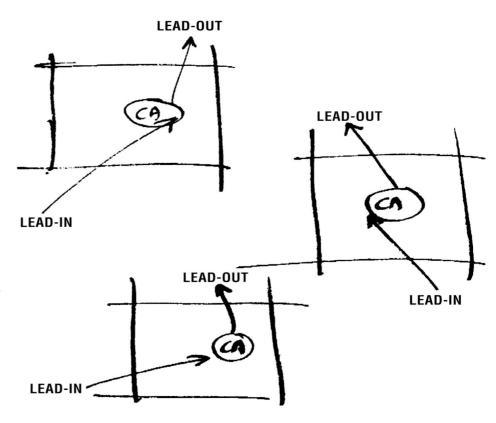

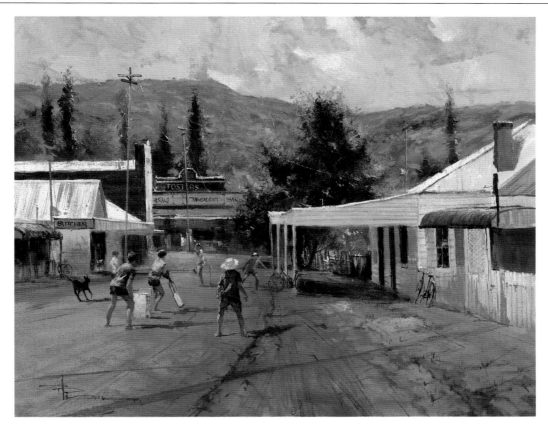

Here's an example of placement theory in an actual painting. The command area in "Murrurundi" (Chapter 13) is the game of cricket and the attendant participants. The eye is drawn to this area by three lead-ins, (see the diagram below left). Maximum highlights and contrast and colour switches take place here.

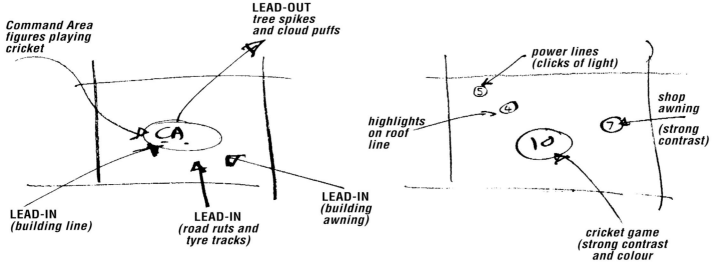

Examine these lead-ins and lead-outs.
There can be any number of lead ins as there can be lead outs. Every successful painting must have them.
This idea also applies to command areas. Smaller command areas serve to amplify and support or enhance the dominant area. As the diagram above right shows the painting contained several supporting commands. The numbers refer to the relative strength of these extra command posts which collectively support the dominant command post, and excite and hold the interest of the viewer. We'll go more into relative strengths in a minute.

You'll see how important the inclusion of figures are in painting after you have followed the progress of my demonstrations.

The early stages of my paintings are all about setting the scene, but when I introduce a figure, suddenly I have put the scene in context!

The very first figure you introduce is the command post. It is from this first figure that everything else is keyed. For instance, in the demonstration painting, "Murrurundi", the very first figure was that of the bowler. Once he was established I painted in the batsman and suddenly the bowler became less significant.

The command post sets the direction and the context for the entire painting — it's like a chess game really, you move the Queen, and the Queen defines where the rest of the pieces will be!

About Command Areas and Balance

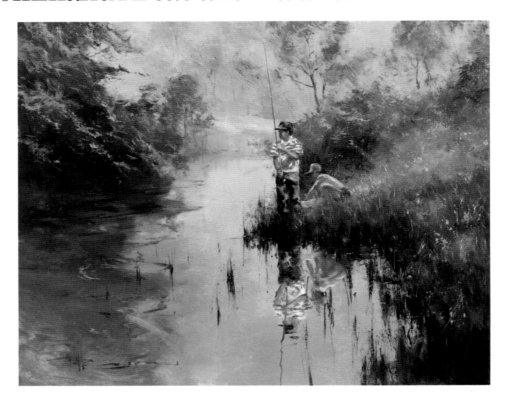

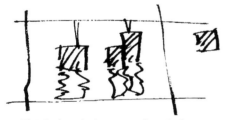

Think about balance — where is the dominant weight?

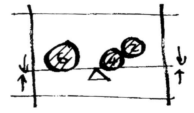

The small triangle represents the fulcrum. On the right we have a combined weight of 6 (4 + 2), on the left a weight of 6. They are equal, therefore they balance.

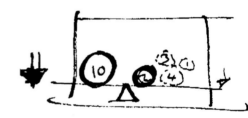

But say we have this configuration. We are heavy to the left by 8 (when we count only the heavily circled numbers). More command areas need to be on the right of the fulcrum to achieve balance and harmony.

Thus the circled 2 is joined by 3 + 4 + 1.

4 could be a dog.

3 could be a bucket.

1 could be a bird.

Then we will have BALANCE.

We now have balance horizontally, but do we have it vertically?

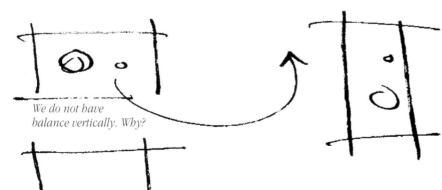

We do not have balance vertically. Why?

Weight to the right. The eye works in every direction — consciously and unconsciously.

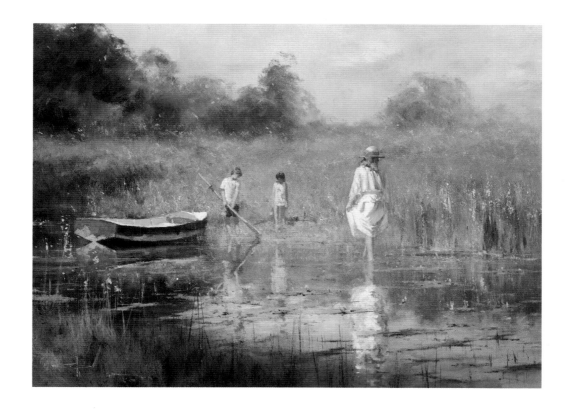

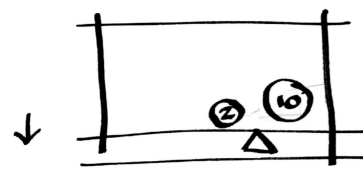

Let's use the painting above as an example. Say we envisage the scene with the girl with the white dress and hat and the smaller girl to her left as the only figures then we have too much weight to the right of our imaginary fulcrum. If the smaller figure was given a weight of say *2* then the larger figure would be about *10*, as shown in the diagram here.

2 ⟨ 10

More command areas need to be added to the left of the fulcrum to achieve balance and harmony. So the circled *2* is joined by elements weighted as follows:

 3 for the second figure holding the oar
 4 for the boat, and
 1 for the yellow flower highlights in the left foreground.

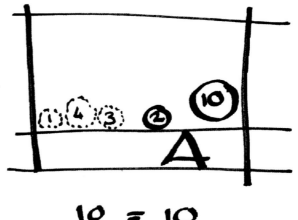

10 = 10

CREATING FULL FIGURE PRESENCE

"Black Rock"

You're about to find out how important figures are in telling a story. The early stage of this painting was all about setting the scene, but when I introduced the figures suddenly I put the scene in context. The first figure introduced was the Command Post, and from this everything else was keyed. So, in this exercise I'll show you how you can create full figure presence and tell a story at the same time.

It was easy choosing the first exercise in this book. Early in my career the very first painting that I was happy with was one I did of the beach, somewhere between Brunswick Heads, New South Wales, and Byron Bay, a stretch of about six miles of beautiful low wide beach interrupted only by the "Black Rocks". This was where I learnt how to catch tailor fish. As my dad said, "These fish fight!" After they're hooked they run towards you, making you believe they are not on the hook, then they switch and head out to the ocean and surprise the life out of you. So you must be ready when you go fishing — especially at Black Rock!

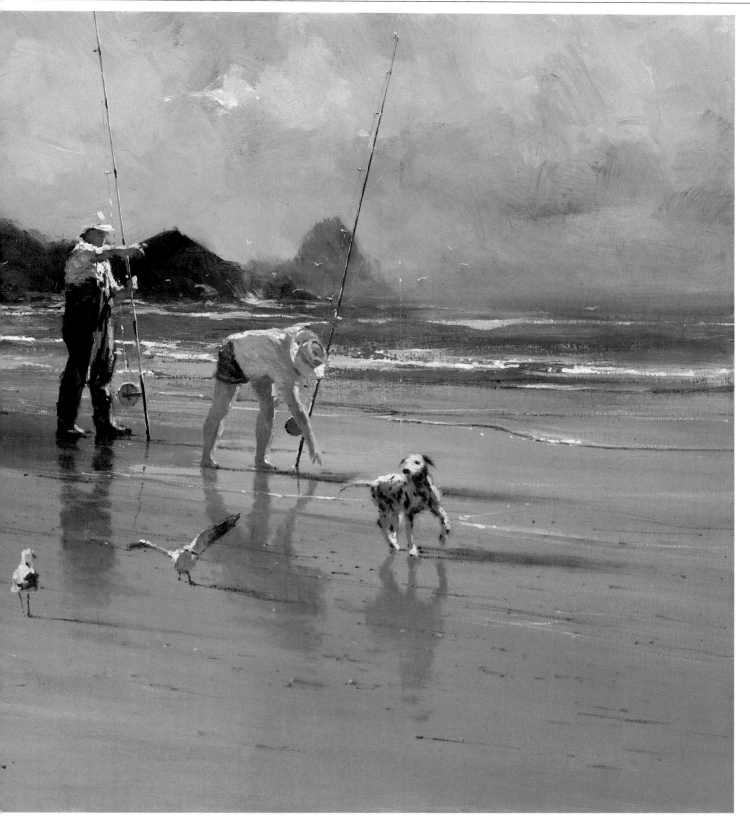

"Black Rock" Oil on canvas 24 x 30"

*"The eye of the viewer is invited to wander over the painting
and 'discover' all the little command spots."*

Gather Information with Sketches

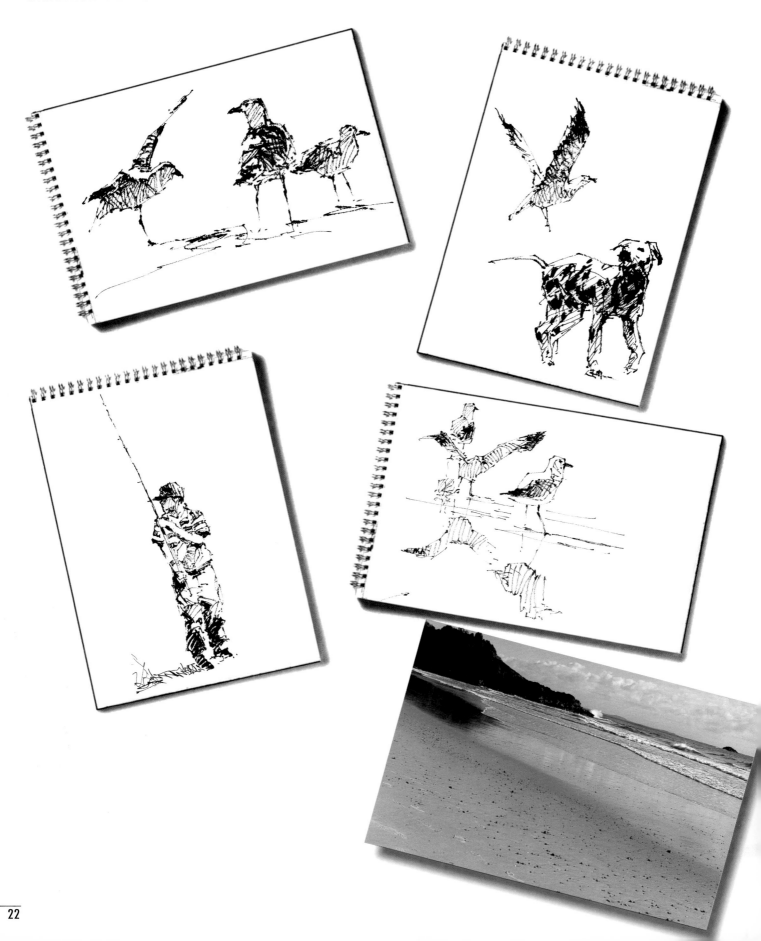

Use Photographs for Reference

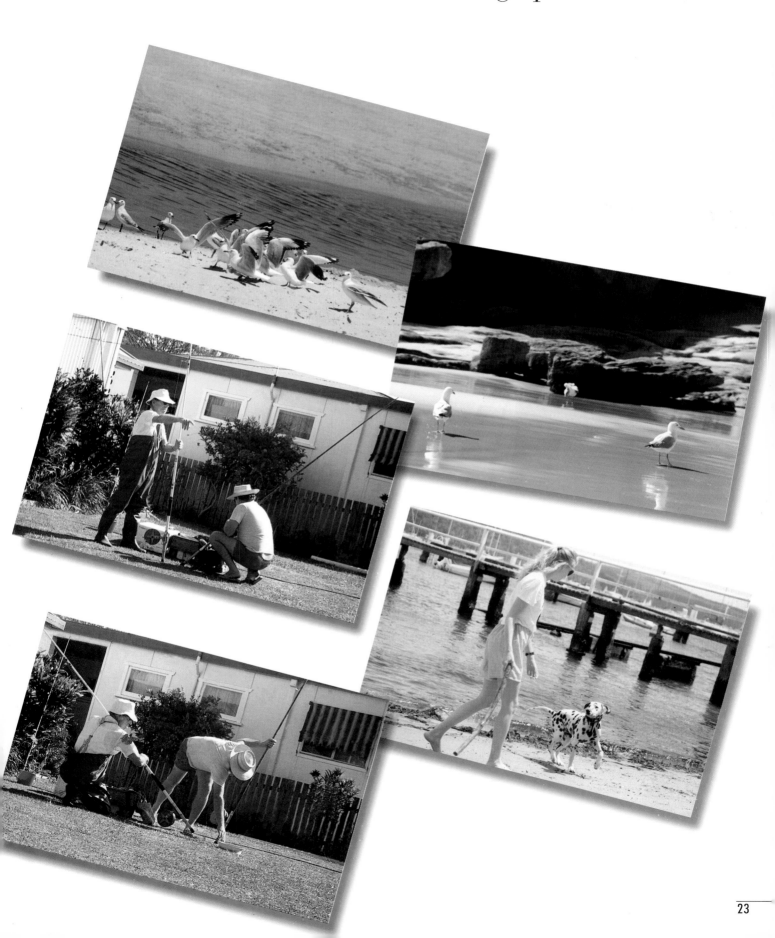

The Step-by-Step Demonstration

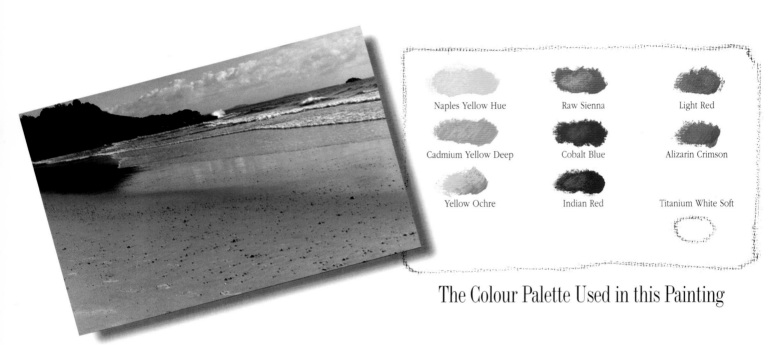

Naples Yellow Hue

Raw Sienna

Light Red

Cadmium Yellow Deep

Cobalt Blue

Alizarin Crimson

Yellow Ochre

Indian Red

Titanium White Soft

The Colour Palette Used in this Painting

Using a grey mix I sketched in the rough outline of the headland, water and beach — the main background components.

Next I mixed a grey from the Cobalt Blue and Alizarin Crimson/Indian Red and white, and applied this to the sky area. My strokes were forward, backward, up and down — varied in other words, replicating nature.

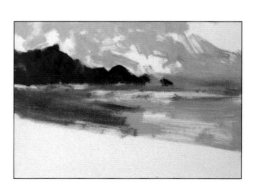

The same colour with a little less of the white was bedded into the sea area. I mixed a dark value of Cobalt Blue and Alizarin Crimson and backed in the headland ensuring there was a raggedness about the form, as nature has a habit of treating such promontories.

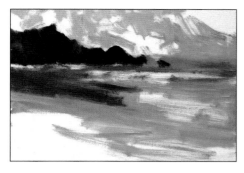

In its pure state the sandy foreground was a mix of Yellow Ochre and Indian Red. However, in this painting it takes a bit of grey from the sky and the water, because it bridges the water with the immediate foreground. The waterlogged sand was a "bleed" of grey and Yellow Ochre.

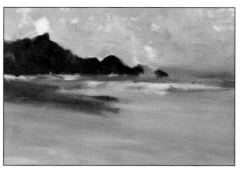

The close up foreground bears more of the pure sand colour.

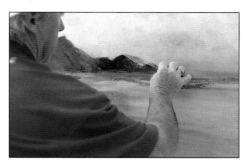

Then I went back into the middle distance and slid in some of the colour of the headland with a palette knife to tie in these adjoining areas.

I ran the knife down into the forewater in an attempt to impart the look of broken water.

The effect of the knife is obviously a boon. Every instrument has its idiosyncrasies. Learn what they are and exploit them.

What I have done here is an educated accident.

I redefined the distant landmass to create a more interesting shape.

Then I enhanced the shape of the beach with the reflection of the headland in the shallow water; by so doing I tied the components together even further.

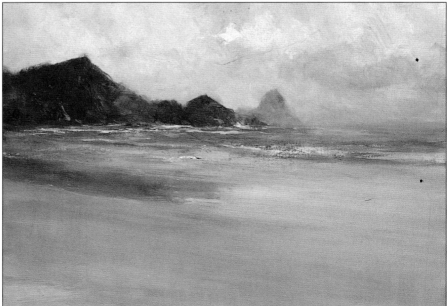

Getting into the figures is not a time to sit about and think. It's as much a natural operation as blocking in the sky. Simply start and do it! I selected the spot in the painting and commenced with the middle values of the figure. From the photo it was clear what the colour value should be.

Over the years I have become pretty good at assembling the photographic equipment and film that gives me fairly accurate prints for various components of a painting. Once I established the basic shape I wasted no time in hitting the highlights — shirt, arm, leg, hat, and so on.

At the end of this chapter you'll find a full step-by-step demonstration on how to do figures. Remember, this approach applies to all figures, be they human, animal or whatever.

Once my "command post" figure was established I quickly looked to see where to place the next figure.

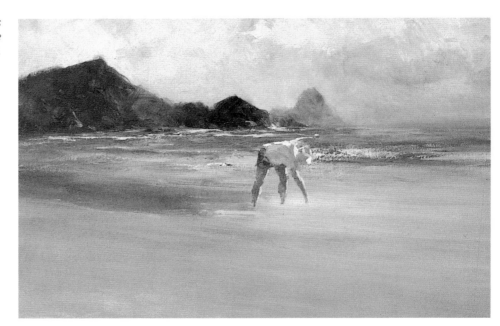

Since the first was a more lateral arrangement, I needed the next one to give some vertical strength . . . about here! This extended my command area which then encompassed the two figures.

I selected an upright posture with strong contrasts, that is, dark wet pants against a light shirt and towelling hat! I used the palette knife to scrape away the area where I intended to apply the paint. Doing this tends to make the inclusion "sit in" rather than look "stuck on". The middle value went in with the No. 2 brush and then I returned with the sable brush and with a fluid mix, redefined and sharpened up the edges.

Creating sunlight on these upper body garments really made them pop out. Notice how I used a support (the centrepiece of a roll of canvas) to steady my brush hand for these intricate strokes.

Don't be afraid to make full use of a hand support.

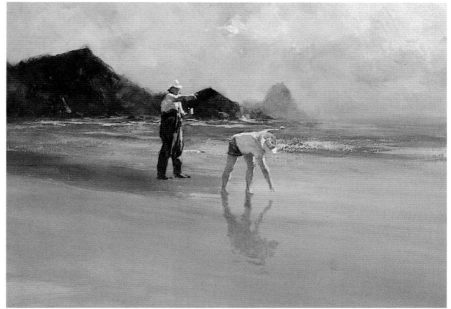

With the same No. 2 brush I headed back to the first figure and reinforced the shape by darkening the darks and lightening the lights. To tie the figures down I went straight into their reflections. Rather than look to repeat their colours I elected instead to use a neutral grey-brown, something more in keeping with the land, and run it down to the base of the painting.

Now we have full figure presence!

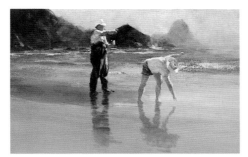

I did the same for the other figure.

Next I needed to attend to the element of the painting that would take us further into the storyline — fishing! So it was time to add more detail. Using the core of my canvas roll as a guide stick I was able to effect a true and steady vertical line. My brush was my faithful sable.

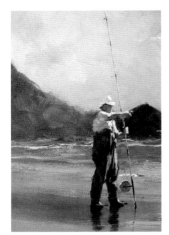

The old beach fishing rods in Australia are side casters. They are barely known, and when described are regarded as a curiosity, so if there are any fishing addicts among you, no, I did not make the rods up — they're genuine.

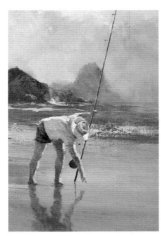

I got the upright figure done, then I worked on the fishing rod for the bending figure using the same technique.

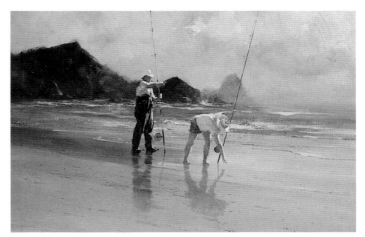

I dropped in the reflections of the rods and the painting was beginning to look pretty complete!

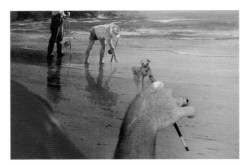 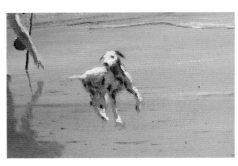

Then it was time to get on and finish this story. Hey, after all, that is what painting is about — recording events around us! Every time I've been on a beach where the challenge is to catch fish I have always sighted a dog! In this case the dog is a Dalmatian and yes, he was mine, at least for a while. As a subject he was always great because he had natural contrast. He was, after all, black and white, albeit in spots. But add on the highlight and we have a 100 per cent support figure.

As we learn from the accompanying figure demonstration "a shape is a shape", and a dog is no different. I used the No. 2 flat to shape him in with the shadow tone (middle value). Then quickly brought him into unison with the figures by highlighting his back, tail, head and legs.

At this stage please note that the most important statement in the painting is still the two figures (No. 1 command area) while the dog is a great secondary statement (No. 2 command area). Every painting should have a whole lot of these command posts, or spots, or whatever we choose to call them. (Go back and re-read Chapter 5 again if you're still not sure on this point.) Once the main command area is in place, all the others will reinforce and support it. They also help to fine-tune the balance in a painting.

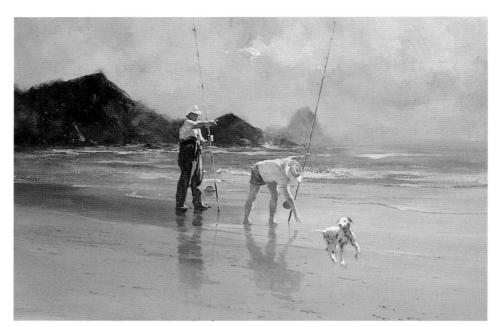

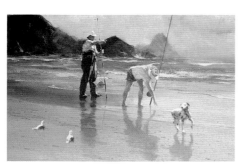

We know that in real life a fisherman is rarely alone so we included the dog. The story line is the fishermen whose catch is being pursued by the gulls, and in pursuit of the gulls is the dog. So what must be present to complete the storyline is the disturbed seagull community!

I positioned the first two seagulls to the left of the vertical figure to add balance — with only the dog the picture is a bit too heavy on the right hand side.

Again, seagulls are just SHAPES, (I could probably paint seagulls with my eyes closed because I have practised them over and over again). Using the No. 2 flat I blocked in the shadow middle value first then come in with the dark of the tail followed by the highlights. Looking good!
Mustn't forget to add their legs!

The relationship between the dog and the gulls needed pushing a little further so I decided to paint in a bird that was startled by the advances of the dog. Yes, that works! I used the middle value grey (Indian Red/Cobalt Blue/white) plus highlights (Yellow Ochre/white) and got it! I was there! Or was I? Not quite. It was time to be patient and finish off.

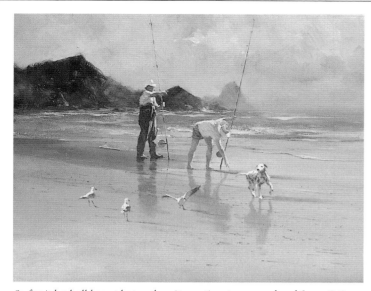

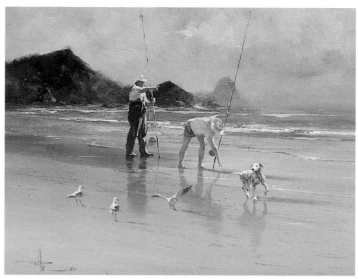

So far it had all been photos, then it was time to use my head (or artistic ability). When you try this, if you feel a bit low on artistic ability don't worry because what you have got so far is pretty good. That ability stuff will come later, hey, it's already started.

Detail! Sand, pebbles and small shells and rocks all have waterline tails after them. Ripples and washlines invade and retreat over the foreshore. Clinks of light in the water, on the rocks, on the headland, on the fishing line, on the rods and reel, on gull beaks, feet and so on, all need to be attended to. All these details add interest and crank up the painting. The eye of the viewer is now made to wander over the painting and "discover" all these little command spots.

Pops of light. Pops of dark. Pops of colour — this is where the artist exercises final authority. Keep on going. But how far to go? When to stop? Go outside and observe and let nature tell you. As Renoir said, "The secret is knowing how long to turn your back away from the window and how long to look out the window".

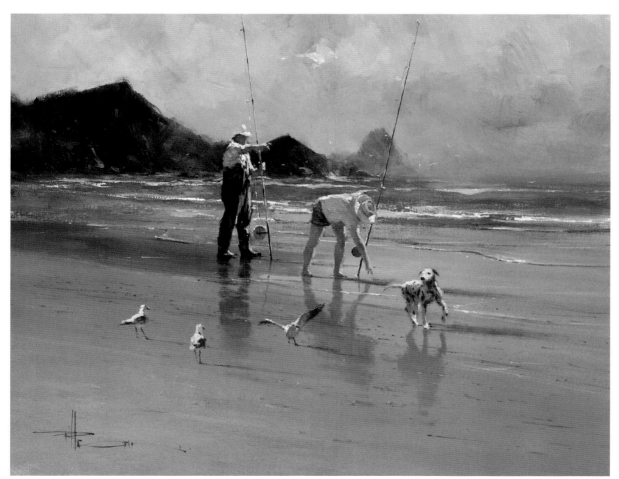

"Black Rock"
Oil on canvas 24 x 30"

How To Paint a Figure

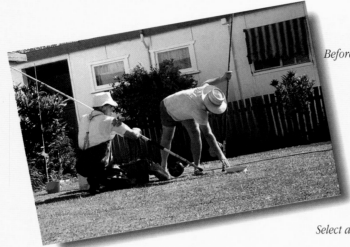

Before you do anything, sketch the figure at least 20 times.

Make a palette of the following colours:

Light Red
Cobalt Blue
Cadmium Red
Cadmium Yellow Deep
Alizarin Crimson
Titanium White Soft

Select a clean No 2 bristle flat brush.

Mix those two important colours, Light Red and Cobalt Blue together to make the essential deep grey. At the same time mix Cadmium Red and Cadmium Yellow together and add a little of the deep grey, then with the flat of the brush paint in the legs. Keep the photo handy as a guide.

Wipe the brush clean. Add Cobalt Blue to Cadmium Yellow and with the deep green that results, paint in the pants. A little bit of the deep grey wouldn't go amiss.

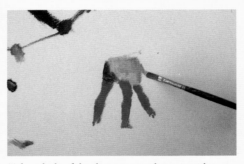

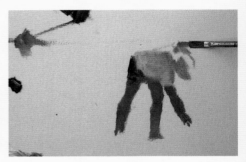

Wipe the brush clean. Mix white with Alizarin Crimson to get the shirt colour (add a little of the deep grey just to take the edge off it). Paint in the shirt.

Mix a little more of the deep grey with some of this pink and dab it around the top of the shirt towards the head.

Take a little of the deep grey and mix it with white, then grab a little of the warm colour we used for the legs. Mix these together and you will get a soft warm grey. Use this to paint in the shadow areas of the hat.

Add a little blue to the grey and you will have an equally soft cool grey. Paint this into the hat, particularly around the bottom part of the hat.

The crown of the hat receives warmth (yellow) from the sun. Remember this figure is on the beach so its underside inherits the cool blue of the water. (Go back and read about inherited colour in Chapter 4 if it's not clear.)

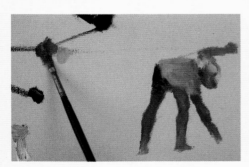

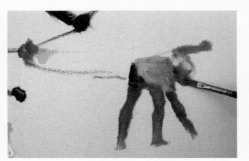

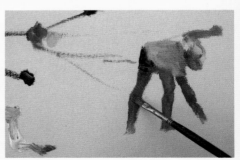

Wipe the brush clean. Mix a little Cadmium Yellow with the light grey and paint in the light parts of the hat.

Paint in the other arm. (If you paint the hat first it will guide you when you paint the arm.) Take some Light Red and Cobalt Blue and apply a touch to the brim of the hat.

Take some of the cool grey (Light Red/Cobalt Blue/white but on the cool side) and work it into the legs and pants and underside of the shirt. Take care not to overdo this — it just needs to take the edge off the raw look of those areas.

Clean your brush. Mix white with the Alizarin Crimson.

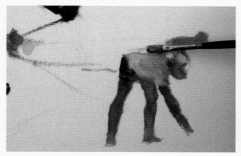

With a horizontal stroke lay the highlight on the back of the figure. A touch of yellow in the white wouldn't go amiss.

Mix a highlight skin colour using Cadmium Red, Cadmium Yellow and Titanium White — never buy that "skin tint" available from the art shop.

You can virtually drip these highlights on. Start on the highest arm first.

Next, highlight the outstretched lower arm.

Then highlight the legs and feet.

Stand back and look. This should be about the twentieth time. Looking good!

Next the hat. Cadmium Red makes a stunning headband. Then with a mix of Cadmium Yellow and Titanium White drip on the highlights to the brim and the top of the hat.

Now the figure is really popping. This is how all "shapes" can be tackled. Don't allow yourself to be intimidated by your subject!

DEALING WITH A BACKLIT SCENE

"By the Brook"

In this chapter you will learn about the power of reflections! I'll also show you how you can take water to the very edge of reality to enhance the storyline. Placid water, ripples, turbulence — all these factors play their part in what you are attempting to say. On a practical level, this chapter will also give you important information about ascertaining what colour reflections should be.

The setting for this painting is the extremely beautiful Dedham River in Suffolk, England. Yes, this is Constable Country! There's a little hamlet outside Ipswich called Sproughton where I found this meandering stream. Over the past ten years or so I have witnessed its changes and its evolving beauty. Many of my romantic style paintings have their origin in the mile or so I annually walk along this stream's banks.

"Highlights make a painting 'pop'!"

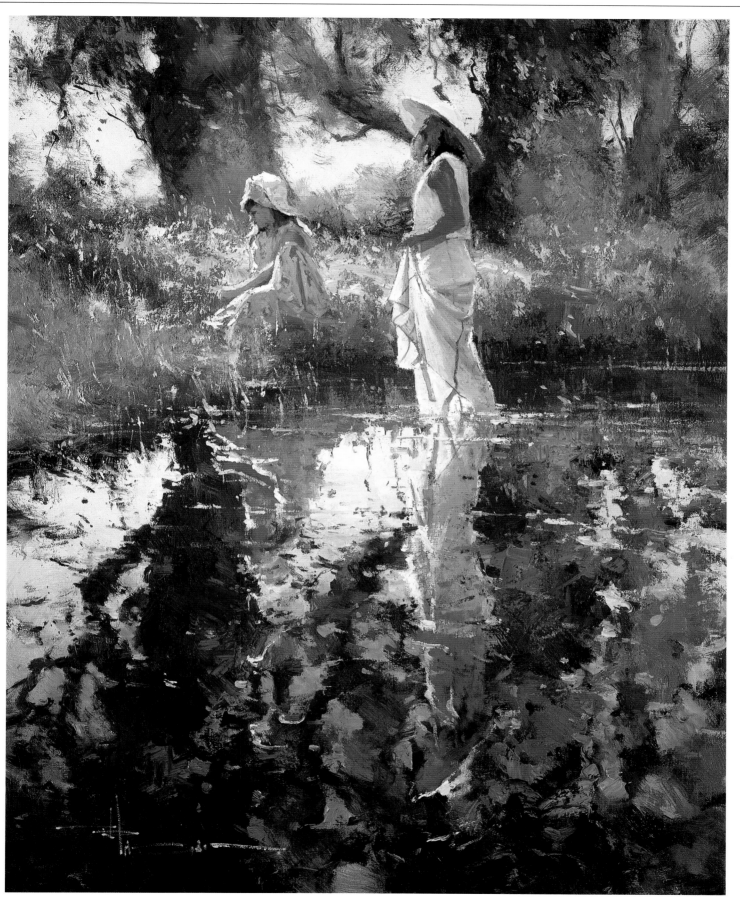

"By The Brook" Oil on canvas"

Reference Sketches and Photographs

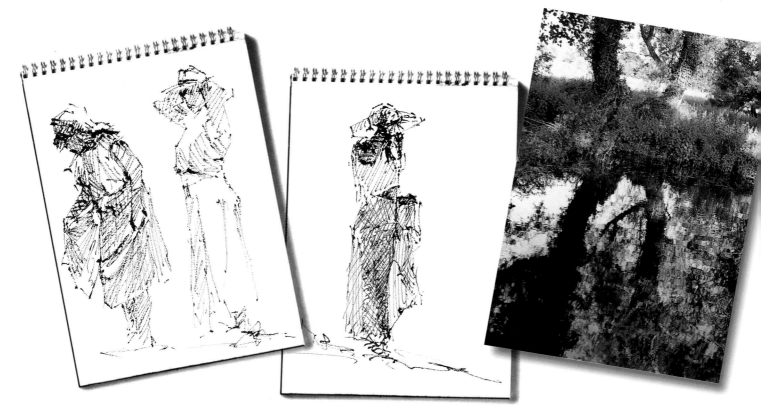

The Step-by-Step Demonstration

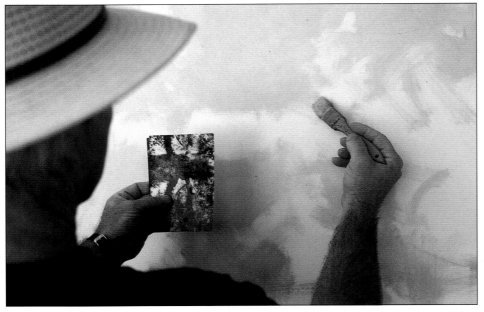

From the site photo you can see there's a fairly clear structure to the setting. Water dominates, with a small area of sky to the top. The trees, with their accompanying mass of broken foliage and grassy area at their feet, dissect both. I blocked in the main areas starting with the sky and covered the parts that I intended to keep as sky with Naples Yellow interspersed with a light pastel blue (Cobalt Blue and Titanium White). I kept loose and "bled" those colours into each other. This was accomplished with my 1" bristle brush obtained from the local hardware store for 59 cents.

I worked the brush up and down, sideways and "everyways" to effect the feeling of temperature change in the sky.

I did the same with the reflected water area below but went to a deeper blue at the very bottom.

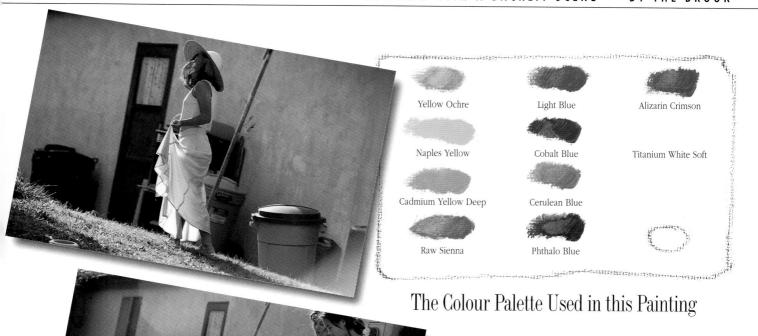

The Colour Palette Used in this Painting

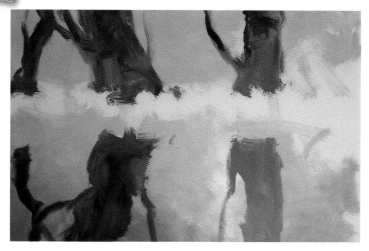

The areas left vacant were filled with the trunks of the heavy trees. To do this I mixed Light Red, Cadmium Red and Yellow Ochre with a bit of Titanium White just to lift it a bit, and blocked in. For the deep values I added a blue mauve to the above mix which I made from Alizarin Crimson with Phthalo Blue.

When you're doing this it is important to keep the spontaneity as you move along.

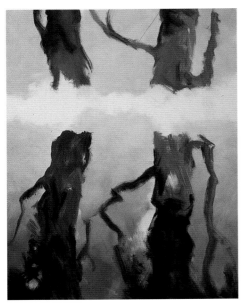

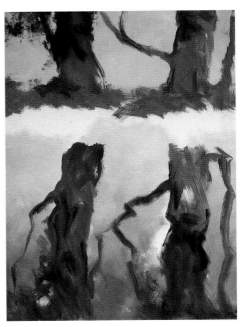

By this stage I had only spent about 15 minutes on this painting.

I started to tie these areas together with the stream's grassy bank and the accompanying reflections. My Cobalt Blue was charged up with Yellow Ochre and slapped on. I mixed up another couple of related greens and added some extra zap in the area (Blue Light with Cadmium Yellow Hue and Cerulean Blue with Raw Sienna). I returned to these colours throughout the painting whenever I dealt with leafy areas, in or out of the water.

The story so far.

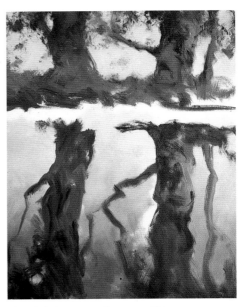

With the same mixes I embellished the branches and limbs.

Photographs help as a reference for form, but give little information in terms of temperature variation. That is up to you and me! I roughed up my 1" brush by pushing its side bristles against the palings of the fence making 20 or 30 bristles stand out from the brush. You can clearly see this in some of the close-up photos of the brush throughout the book. When the splayed brush is loaded with paint and pushed and twisted into the limb and grass areas, the paint is deposited in a way that leaves the impression of broken cover! It's one of my favourite manoeuvres.

I headed down into the water. This area needed a different treatment but essentially I approached this with a blocking technique.

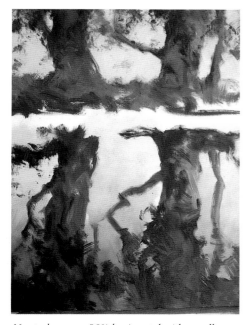

I loved doing this part because it involved using colours of equal value working against each other with abandon — water has that quality. I painted these colours over the darks that were already in place.

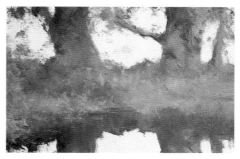

I hit an area that had more strength, the area jutting out into the water. With a very deep mix of Phthalo Blue and Alizarin Crimson I skipped the side hairs of the brush into the light areas of the water setting up an area of high contrast. This broke the monotony of the bank in both colour and uniformity.

My strokes were 90% horizontal with a well loaded brush. I alternated between the 1" brush, and No. 2 and No. 4 bristles. I wanted the look and feel of still water near the bank, but for the canopy reflections I needed chunky looking water, after all, that is how it looked in real life.

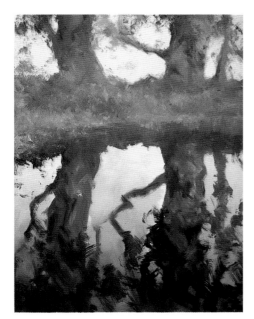

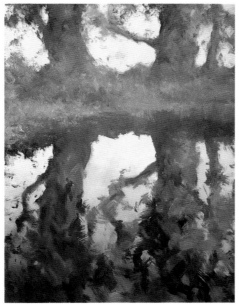

I returned to add some "preliminary final" type touches.

I kept going with blocking in the colour in the water. Extravagant bold strokes did the trick, and I varied direction all the time.

If you love working with paint then you will enjoy this!

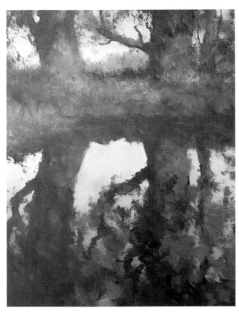

Look at the raw spots of colour strategically placed amidst the foliage on the bank.

Compare this subtle background with the photograph and see how the painter's eye can be trained to enhance reality.

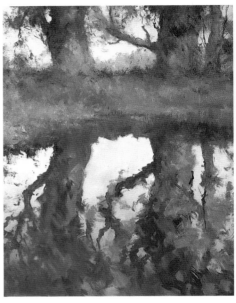

The painting was now ready for the next step and I was ready for a quiet afternoon beer. Believe it or not although I enjoyed doing this painting enormously the drain to stay loose had been commensurately enormous!

Among my reference photographs I looked for a figure that would pop out of this setting yet harmonise with the mood. The one I chose was of my daughter Michelle, and although she was nowhere near water, I felt she would look dynamite if positioned ankle deep in the water of the painting. This lateral thinking is a key consideration when you work with photographs. The skill is in realising how each photograph can be used to best effect. Don't be afraid to "flop" figures so they face the other way, make them bigger, smaller or, as in this case, alter the setting!

Starting with the middle value or shaded part of the dress I moved upwards to the yellow blouse, the shaded arm, the dark of the hair, the red

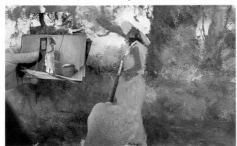

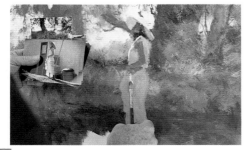

ribbon and to the straw hat. These were all done using each particular area's shadow value and colour. That's simply the true colour greyed back with a little mix of Light Red and Cobalt Blue and Titanium White. Look at the section on how to paint figures and you will catch on pretty quickly.

I'd been looking forward to painting this particular pose for some time because of the lean of the body and the tilt of the head. There's a beautifully relaxed forward movement to the figure: a motion that seems to fit in with the other shapes in the painting.

To make sure I was on track I wasted no time in laying on the highlights on the hat, the blouse, and the skirt.

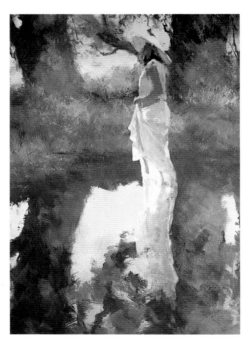

I blocked in Michelle's reflections. The colours in the water were the same as those above, but in general one value lower — darker, in other words. (Refer to my value scale in Chapter 4.)

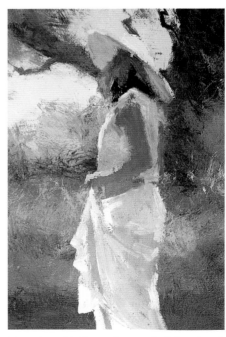

Notice how this figure does not look "stuck on", even at this stage.

Looking through my photos I came across a great support figure for Michelle — my good neighbour Don and Betty's grand-daughter, Courtney. I felt the painting needed more, it needed something coloured in a relatively neutral attire. We have sufficient colour pop and the mauve of the dress sat well with the grass.

When I hit her bonnet with the highlights the figure bolted out of the painting!

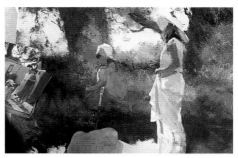

Highlights on the mauve pulled her right out of the grass and helped link her with the standing figure. Check how I did the highlights.

Don't dare sit down while you are doing this — stand firmly upright and keep walking away to look at how it is all going.

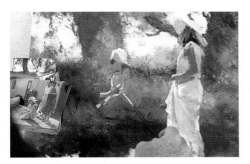

Again, refer to my figure painting demonstration.

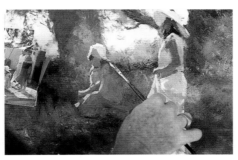

Shape and mould — just enjoy yourself!

In this detail shot you can clearly see that the figure is merely a collection of suggested shapes.

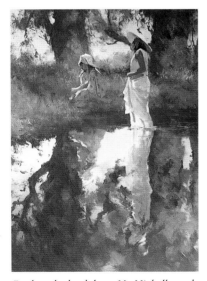

Back to the backdrop. My Michelle and Courtney command areas were going at full throttle, highlights and all. If anything, they were a bit too much in front of all the rest.

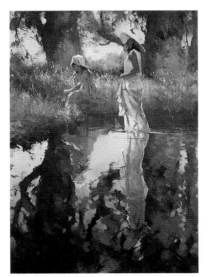

I decided to "crank up" the backdrop to the piece. I started by skipping a Light Yellow (Cadmium Yellow with white) with my roughed up 1" brush in vertical motions behind and around the girls. This made the figures sit into the painting better. With a yellow/green (Cadmium Yellow and Light Blue) I repeated the process over the same area. I decided I would come back later with the sable and "tinkle" this some more.

Dots of dark and spots of light were popped throughout the reflections to add to the feeling of being busy.

I worked on each of the reflections, and particularly enjoyed Courtney's subtle mauve reflection.

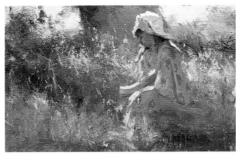

This was serious finishing off stuff now! First I used my sable brush with an Alizarin Crimson based pink to add the little flower designs on Courtney's dress. This gave more character and brought more excitement and interest. Just look at that lovely background too!

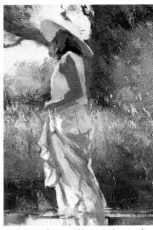

Adding the trailing wake in the water behind Michelle placed her firmly in the water, and gave some highlight kicks.

Don't be afraid to use all your tools because you'll add an exciting dimension to your paintings by varying your strokes. Here I went for my knife and loaded up with a light cream/blue and laid in the areas separating the figures reflected in the water.

I advanced with the same approach into the reflections of the tree canopy. My painting knife was perfect for laying on strokes of colour in these chunky reflections. I loaded up with colour and simply wiped across the canvas.

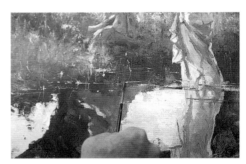

Look what I achieved by bouncing around the whole painting with all my instruments, dotting here, stroking there, and so on, looking to achieve how I feel about nature and light.

The small sable was used to detail up the grassy bank and provide lead ins.

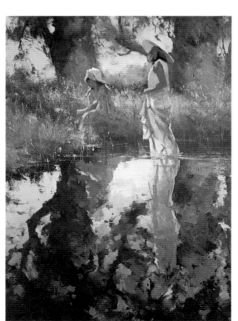

The story so far.

At the end I returned to finish off the reflections of the two figures.

They're done.

These highlights made the painting pop! I was very happy with it.

Some finishing touches on the reflections and it was done!

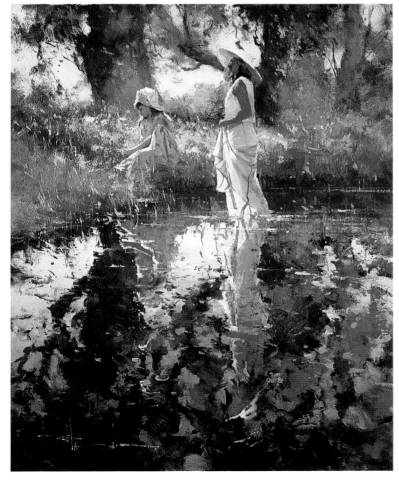

*"By The Brook"
Oil on canvas*

Painting Reflections

This is a simple lesson. The basic rule is: whatever the value of the thing is that is reflecting in the water, drop it by one. This will give you the correct value of the reflection!

Let's look at some other reflection idiosyncrasies. Water has no set state. In its still form it has a habit of repeating that which lies above it in a fairly honest way. However, if there is a part of nature which is totally loose then this is it. You can literally do what you want with it — bend it, shape it do whatever you want!

Look at the figure on the bank, and then drop a value for each reflected part of the body. To get the drop in value in the figure in this demonstration I went back to the Cobalt Blue/Alizarin mix — my mother colour — I added a little bit of this to the colour I wanted to reflect in the water. I started with the legs then the dress, followed by the hat then the head.

When tackling the highlights I worked methodically, starting with the hat then the dress and so on. Highlights should also take on a bit of the "mother" mix but I dulled each down by "snipping" a bit of the colour that each highlight was to accentuate

There's a technique I've developed over the years on how to paint these reflections. I keep them chunky and sort of off-line. The closer the reflection is to the source, the more faithful it is. The further away, the more it has a habit of breaking up and replicating.

Never underestimate the power of water and reflections in a painting!

You Can 'Turbo' a Placid Scene with Colour!

"King Parrots"

Landscape scenes that bring us a sense of personal tranquillity and joy can often look deadly dull translated on canvas — what they need is livening up, and this demonstration is a perfect example of how to do it. I enjoy painting this type of picture. The fun comes from the spontaneity and the fact that for some reason these vertical formatted chunky type arrangements fit into the way I perceive the natural order. I can't remember where the landscape scene photo was taken. I do know that the photograph comes very close to being a painting in its own right but, like most landscape scenes that rack up high points on the aesthetic scale, it is fairly static. That's when I looked around for something that would bring the scene to life. And I came up with the birds.

The reference photograph is of the aptly named Rainbow Lorikeets that help make my home-town Sydney the colourful city it is. Many residents enjoy their company as they search for seed hand-outs. Every evening hundreds of Lorikeets fly noisily and colourfully to their roosts in the famous Norfolk Island Pines along Manly Beach.

I took the liberty of changing certain colours for effect, and renaming the birds — that's the artist's prerogative.

"Your birds must sit in, rather than look stuck on."

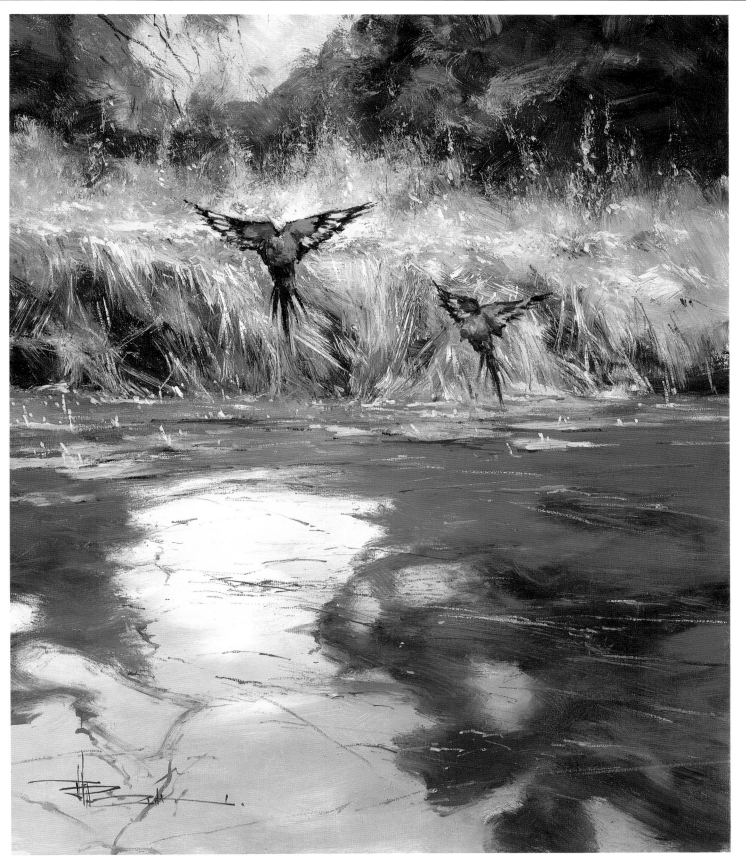

"King Parrots"

Reference Photographs and Sketches

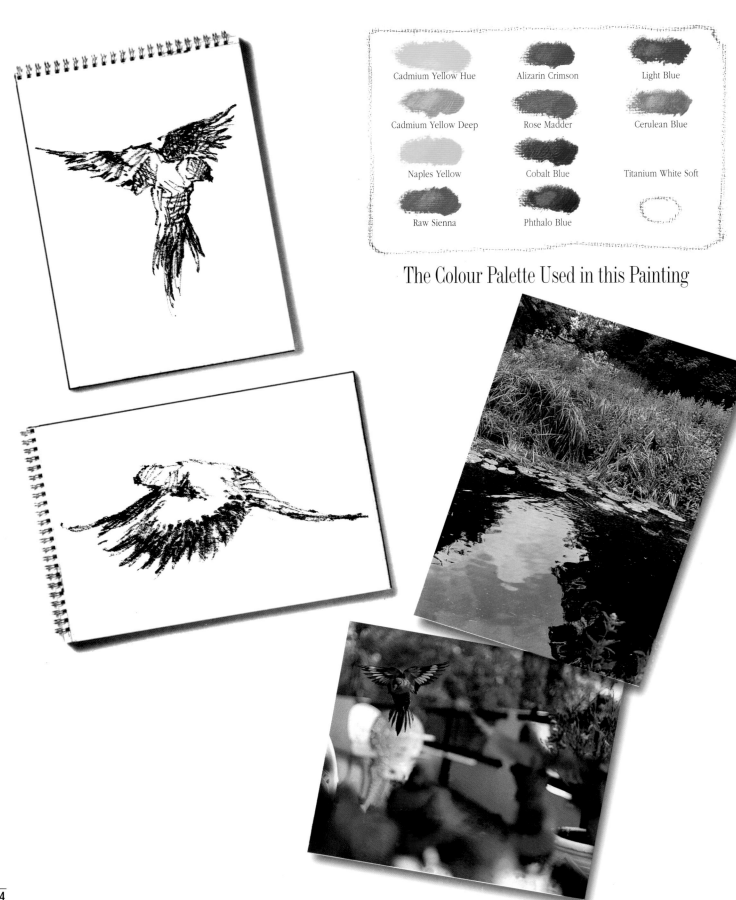

Cadmium Yellow Hue

Alizarin Crimson

Light Blue

Cadmium Yellow Deep

Rose Madder

Cerulean Blue

Naples Yellow

Cobalt Blue

Titanium White Soft

Raw Sienna

Phthalo Blue

The Colour Palette Used in this Painting

The Step-by-Step Demonstration

Using my 1" brush I formed a small window in the sky with Naples Yellow broken down with a little Titanium White.

For the dark wall of trees edging into the sky I applied push-pull umbrella strokes of a mixture of Alizarin Crimson and Phthalo Blue, and alternated these with strokes of Cobalt Blue, Cadmium Yellow Hue and Raw Sienna.

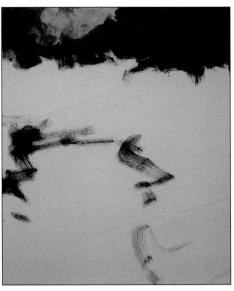

I dragged a little of the dark colour down into the foreground to delineate the sky area in the water.

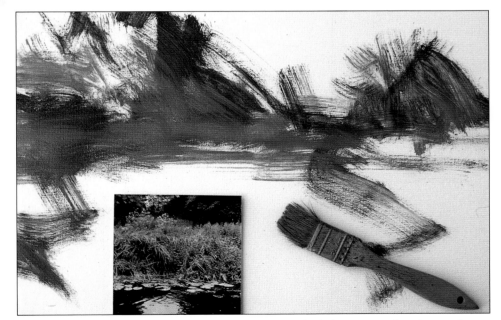

The reference photo gives a hint of dying brown reeds under the lush green growth at the waterline. This was a gift, and I intended to work it up as a nice counterweight to the cools of the entangled grass and reeds above.

In this picture you can see the working photo and my old standby brush, together with the colours and strokes employed. Keep loose!

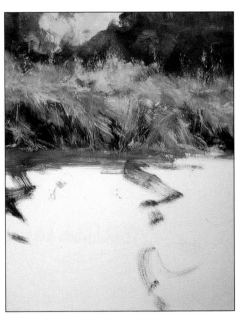

Creating order in the tangle of reeds required building on the accidents that would hopefully happen from extreme looseness and variety in brush strokes.

On the accompanying pages you'll see a complete demonstration on how to tackle reedy grasses like this.

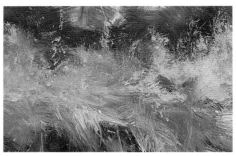

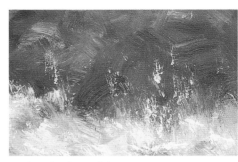

The dark underbase of the reeds was set in. The next layer was a set of middle value reed colours based on yellow, blue and green that resulted from these colours mixing.

Throughout, I used my 1" brush loosely, varying direction to create this busy, but coherent effect.

After roughing up the edge bristles of the 1" brush I skip-loaded and then, with the edge hairs, vertically dabbed on pink/yellow up into the deep foliage above. I wanted these to look like individual stands of flowers.

Look at this beautiful texture.

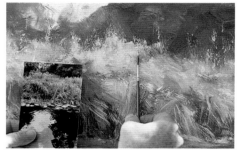

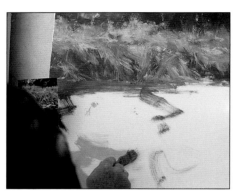

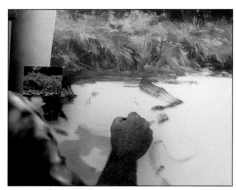

Back to the reeds. By grabbing higher values and sliding the brush at various upward angles I hoped to effect the look of blades of reeds bending and twisting.

I dropped some "clicks" onto the bends to accentuate the grass.

If you look at this picture and examine the reeds you will clearly see that the yellow is dominant above the water, and the blue dominates closer to the water.

In the reference photo there were some very inspiring reflections in the water. To me this is part of the poetry of nature and another reason was I was so attracted to this scene.

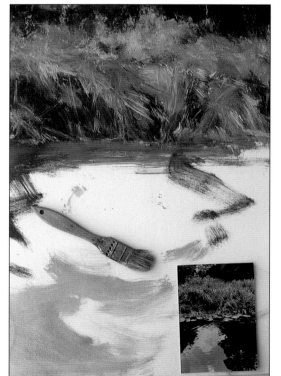

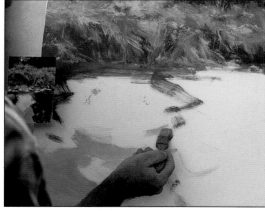

I merely suggested the direction I would take with the reflection, then I blocked in the light blue reflection of the sky.

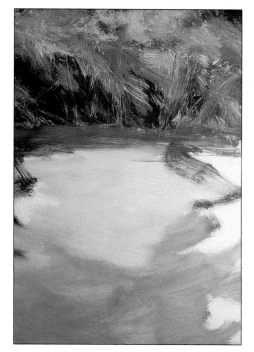

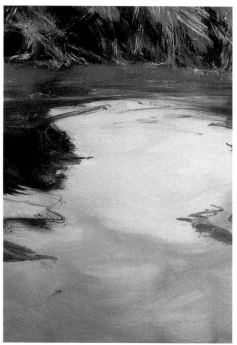

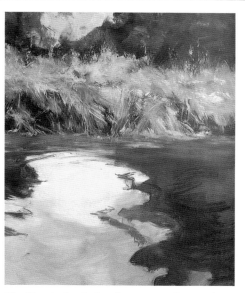

I blocked in the soft yellow from the fluffy clouds unseen above.

Both these fill-in colours were very close in value and so sat perfectly together.

Blocking in the dark reflection was done with a series of loose semi-circular strokes using the full blade of the 1" brush. Just like the previous reflections — colours were the same as those used in the foliage above, just deepened a little. I stood back and looked for the twentieth time. It was time to pull other areas into line.

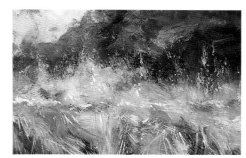

I created a number of lily pad shapes, strengthened the rust colour in the water near the bank, then continued this colour forward with my detail brush. I looked to drag across dried reeds, leaves and sticks over the surface of the water to soften the demarcation between the light and dark reflection areas.

See how every line is used to best advantage, but still does not look laboured over. Choose a colour and put it in. These little clicks of light really lift the darks.

I broke into the darks with spots of sky to assist in relieving any monotony that often develops in large blocked areas. To further add interest I wove an orange-tinged green/brown through the dark. Then I picked up a positive pink and enlivened the little flower sprays in the reeds.

I took a short breather while I decided on what I would use to bolster this placid scene and take the painting to a new level of cerebral interest. One of Australia's incredibly beautiful parrot family would be perfect and give a compact explosion of colour.

The question was, where to put it? Against the water? Or perhaps the tangle of grass? I decided on the latter. Perfection, against nature's apparent disorder, contrasts and underpins many great paintings (not that this aspires to that level). My intention was to create an effective command area, so I scraped off a small area, and blocked in the parrot. This process is shown in detail at the end of the main demonstration.

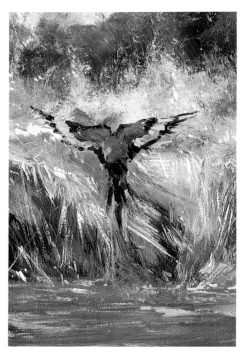

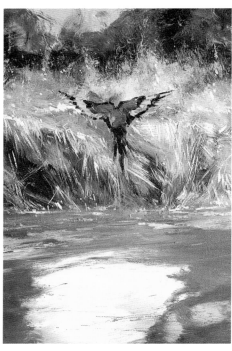

In went the second bird.

Looking good. Now refer to the special demonstration for this bird and how I went about doing it. It's really simple.

Here's how the bird looked in-situ. But I decided the eye was not held long enough with just one bird. I pondered the idea of another bird a little behind and slightly askew to enhance the "pull" in this area even further.

How To Paint Reeds

This is the palette I used for the reeds:
Raw Sienna
Cobalt Blue
Light Blue
Cadmium Yellow Deep
Alizarin Crimson
Titanium White Soft

1" brush and small sable brush.

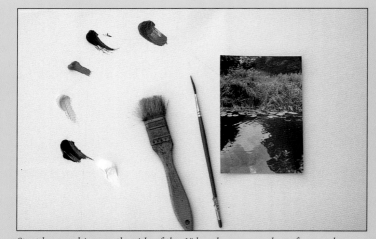

Start by roughing up the side of the 1" brush on a rough surface such as a house brick or fence paling.

Using the flat of the brush, block in the dark areas using upward slanting strokes. The mix is Raw Sienna and Cobalt Blue

Then drag in some Alizarin Crimson. Rotate the brush to skip paint from the renegade bristles.

Rough up the side of the brush again. Mix Light Blue and Cadmium Yellow with a bit of Cobalt Blue and white and skip the brush over the darks.

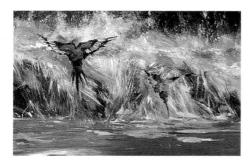

The second bird served to link the water with the reeds, just as the first bird joined the grass to the sky and to the trees.

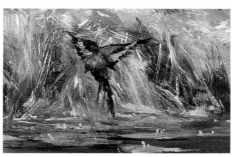

I went to work on the details in the lily pads which were brought down further into the water to soften the drop from the grassy bank into the water. Shadows were painted under the birds to anchor and tie them to the water.
A good looking painting!

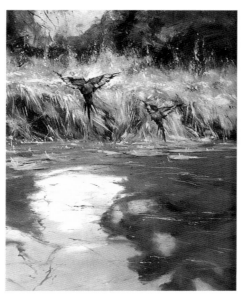

It was time to finish off and detail.
Because the two parrots were so small a part of the painting the detail needed to be spotted everywhere to join and tie the individual bones of the painting together.

Vary the strokes, pushing and pulling, but lightly! Use the paint load for one or two strokes.

Go back and rough up the bristles again, reload and skip some more.
 The fewer the strokes the better. Don't follow the brush strokes you used at the beginning, instead work at varying angles to those.

Stand back and look, then wipe the brush. Rough it up again. Skip-load the edge with more white in the blue/yellow mix. Slide and slip the edge down over the merging blades of reeds.
 Stop, reload, and with the loaded edge drop in on a spot and drag and lift the brush downwards. Wipe, rough up, reload and repeat from another position at another angle.

Slide the brush with the same load horizontally to establish the water line.
 Wipe the brush, pick up some Raw Sienna and drag it through the waterline.

With the sable brush loaded with yellow/white reinforce some of the reeds by cranking up their highlights. A pop of light here or there will give the effect of a broken or bent blade. Experiment yourself but DON'T overwork it.

Remember, keep walking away from the easel to see what effect each movement of the brush has. This will ensure you don't tire the piece. By doing these things you can end up with a pretty good set of accidents.

How To Paint Parrots

When you include something like this in a painting DON'T totally wipe off the paint from the area in which you intend overpainting. Leave a little bit of the background paint there because as you apply the paint for the bird, the residue paint will mix and make the subject sit in, rather than look stuck on. Often I'll paint around the subject and mix it in with the colour. Before you start, sketch the shape of the bird at least 20 times.

This is the palette I used for the parrots

Cadmium Yellow Deep Alizarin Crimson Rose Madder
Cadmium Red Light Blue Cobalt Blue
Cerulean Blue Titanium White Soft

No. 2 flat bristle brush

This is the palette I used.

With a mix of Cadmium Red and Rose Madder block in the red on the two wings. Add a little Alizarin Crimson to the mix to deepen the red on the left wing.

Wipe the brush. Clean. Pull a bit of Cobalt Blue over and drop it in to the bird's body.

Wipe the brush. Take a bit of Light Blue and paint in the head of the bird.

50

Wipe your brush clean. Head towards the beautiful Cadmium Yellow Deep. Load up and block in the yellow of the wing feathers and tail feathers. Check your progress with the photo. Stand back and look at the shape.

Wipe the brush and take a little of the Alizarin on the edge of the brush and deepen the edges around the top of the wing and body.

Mix a light pink from the Cadmium Red and white and apply it, working the flat of the brush into the red of the right wing and part of the body. Wipe and repeat, the same process with Light Blue and highlight the back of the head.

Wipe the brush and mix a light yellow from the Cadmium Yellow Deep and Titanium White. With the flat of the brush lighten up the yellow feathers where you see this occurring in the photograph.

YOU CAN CHANGE ANYTHING YOU DON'T LIKE

"Hazy Morning"

One of the most important skills you can pick up as an artist is the ability to be flexible and the nerve to change things you don't like. Sometimes it does take a bit of guts scraping off what you have already done. What if you make it worse? Well, if the composition isn't working anyway, what have you got to lose?

The setting for this painting made itself known early one morning while I was en-route to my kids' tennis tournament just outside San Diego, USA. It was early autumn with crisp light. As I was driving I spotted a little stand of trees out of the corner of my eye. I don't know their variety, but to me the trees looked like they were strung up with coloured lights. It was just the magic of the sun, of course. Anyhow, I pulled over and walked around these two little gems trying to get the best angle on them. As always my

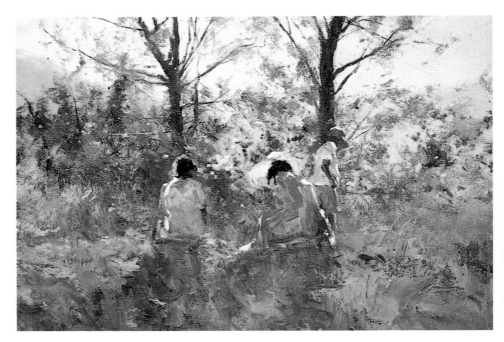

camera was with me. A Minolta Maxxum 7000i loaded with 200 ASA print film. The shot I got was pretty close to what my eye and senses left with me that morning.

The painting I decided to base on this scene would be full of light — I wanted to literally saturate it with light. But, you must sneak up on this type of backlit painting. I'll not only show you how I went about it, but also how I changed the composition half way through!

"What happened next called for a little adjustment!"

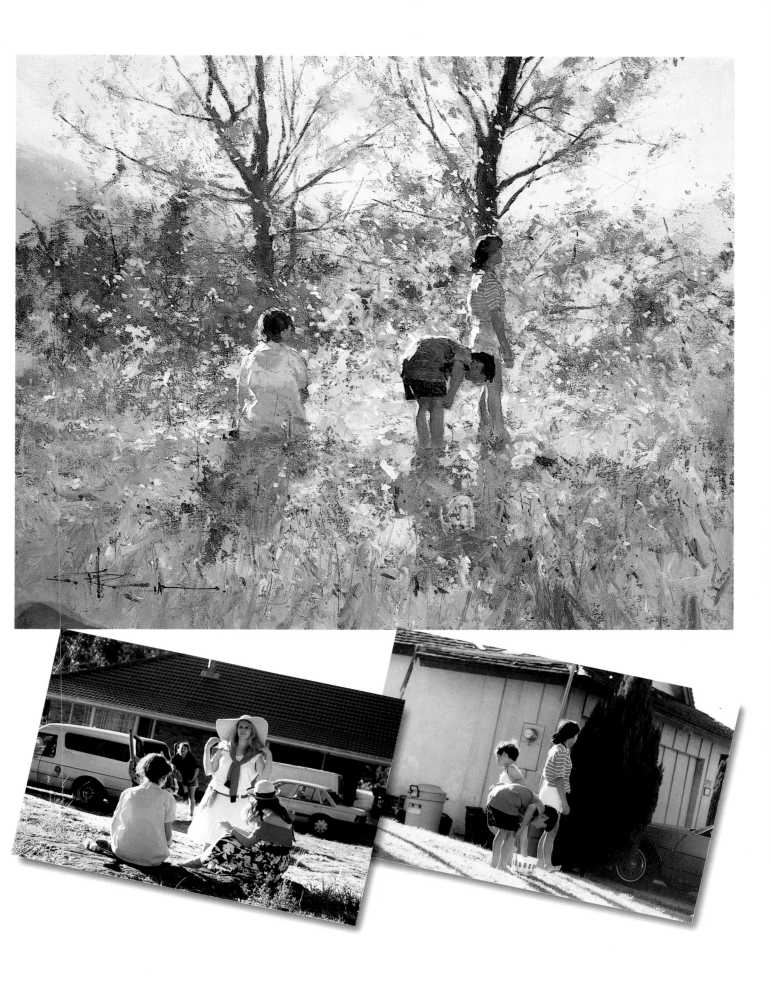

The Step-by-Step Demonstration

I worked in a hazy hill line set against an equally hazy sky using my 1" brush. My mix was alternatively Naples Yellow and broken down Cobalt Blue. I was not seeking any great definition in shape, just a feeling of clear light and colour.

With the same 1" brush reshaped against a rough towel to fur up the edge hairs I dug into a sloppy mix of Raw Sienna/Yellow Ochre/Light Red and skipped the paint upwards into the base of the sky, hoping to replicate the effect of nature's grass.

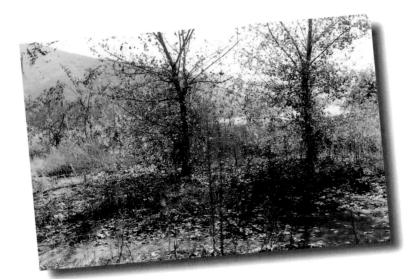

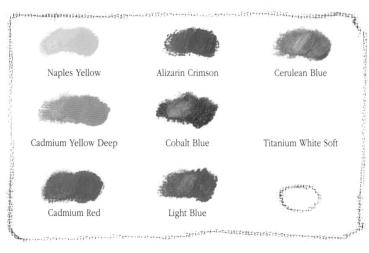

Naples Yellow Alizarin Crimson Cerulean Blue

Cadmium Yellow Deep Cobalt Blue Titanium White Soft

Cadmium Red Light Blue

The Colour Palette Used in this Painting

To take the edge off the colour under the grass I added a bit of grey from my standby Light Red/Cobalt Blue/Titanium White mix. Most of this you won't see but it's important it be there nevertheless.

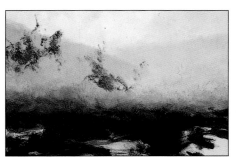

I beefed up this backdrop further by playing with a mix of Cadmium Yellow Deep and Cobalt Blue dabbing in loose straggly branches. This offset the previous warm colours.

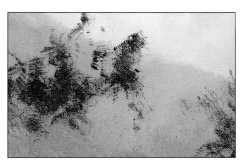

As you can see I kept it loose — this wasn't supposed to be a botanical study.

To complete this laying in process I quickly worked round with a blue-brown mauve to block in the foreground.

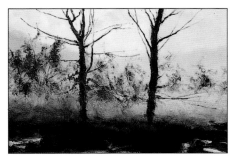

With a deeper mix of the mauve I pulled the brush up to lay in the skeleton of the trees and their accompanying branches. I used both the 1" brush and the small sable to do this. Practice making the fine strokes needed for branches.

I applied highlight colour to the branches.

Just look at this! Roughing up my faithful 1" brush again, I loaded up with a not too accurate mix of Yellow Ochre/Cadmium Yellow/Raw Sienna and dabbled it along and among the branches.

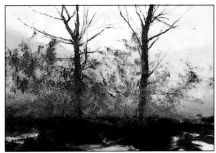

I had established that this is a backlit picture, and had achieved pleasing balance and colour harmony.

I just kept going, building up the grasses and foliage and varying my brushwork.

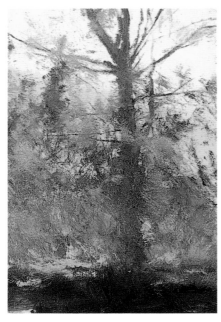

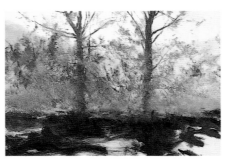

Keep evaluating the whole picture as you go. I thought some more work to bring out the light-coloured grasses would be a good idea.

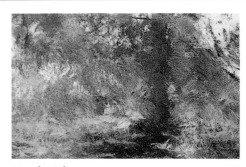

Yes, that's better.

If you study nature you will find you will instinctively do what's right.

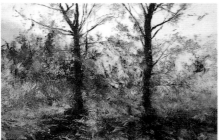

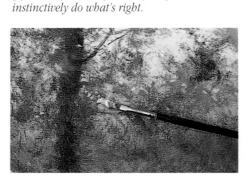

Some more loose work with my roughed up brush created some effective foliage, but I was careful to retain the foreground shadow.

To get some sort of measure of where I was at with the values in the tree foliage, I dabbed on a spot or two of highlight (Cadmium Yellow Deep and Titanium White). I used the small brush for this, but notice how my brush was almost double-loaded so a little of each clean colour was distributed on the canvas. You don't have to mix your paint as if you are mixing ingredients for a cake.

Yes! There's a good value range so I was on track. It's important to do these checks on the painting, but you can sometimes be lulled into complacency. Although it looked right at this stage what happened next called for a little adjustment.

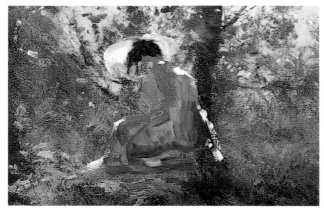

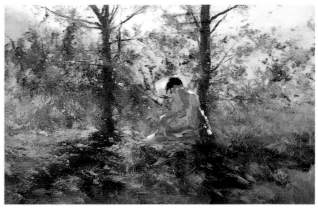

It was time to crank up and animate! I selected a figure from my photo library which I thought would fit. It was a picture of my daughter Michelle wearing a lovely silvery blue dress and featuring her favourite straw hat. I scraped away a bit of the paint, but not all, because I wanted some paint still there to bleed into the new application. With the No. 6 flat bristle brush I shaped Michelle in using the same technique described in my figure painting demonstration in Chapter 6.

Again, I wasted no time in highlighting once I'd got the value range right.

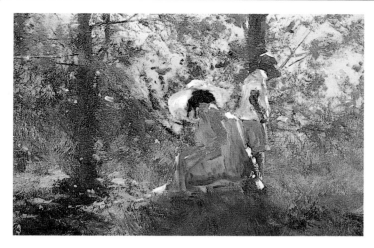

I painted in a second figure behind, and quickly put on the highlights.

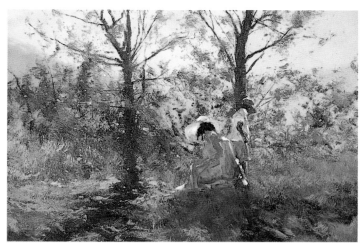

My first command area was established. Then I needed to balance the area.

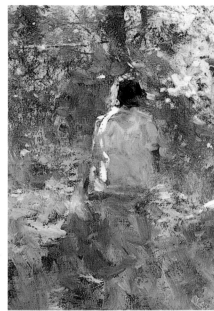

My photo resource provided another useful figure and I quickly blocked her in. A complementary mauve shadow offset the yellow.

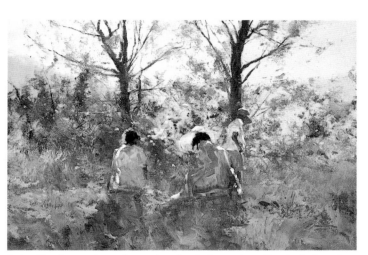

I stood back to evaluate the work so far. Let's see, the yellow looked good, but I wasn't happy with the figures on the right — the blue dress was not convincing. For this to be the command area it needed more colour and contrast. It would still be a good painting if I cared to stay with it but it wouldn't pack the wallop that it could carry! It needed more colour and more points of light/colour intersection.

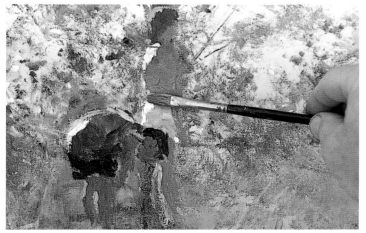

So I reached for the knife and scraped away those figures and referring to my photo library again put in two new ones!
You can see the remains of the blue dress behind the new figures.

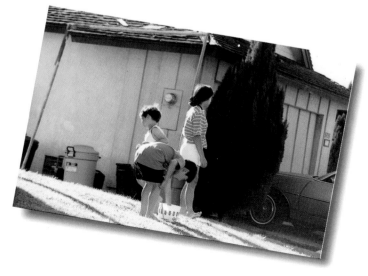

Returning with the knife in hand I began to plant a heavy layer of yellow pinkish light behind and around the legs of the figures.

There, original figures gone!

At the same time, and with some urgency, I picked up and deposited a light blue/mauve and belted it loosely forward and down into the foreground. This represented the shadow cast forward from the three figures. In this close-up you can see the techniques and looseness of the application.

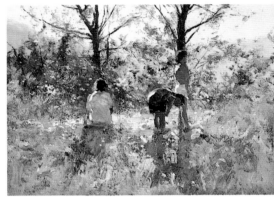

I mixed a light pale colour for the shadows — something the same value as the mauve was what I wanted. This would hold the clarity of this area and maximise its impact. I alternated between the knife and the No. 4 brush here with as much direction variety as possible. I would still have a couple of light values to go when it came time to go back and fine tune and finish off. I decided some highlight was needed over the entire foreground area and loosely worked my way over the painting. Now let's have a look. Much better don't you think?

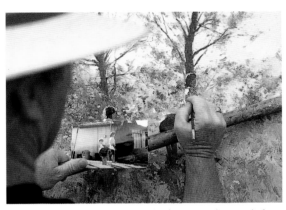

Then it was time to go back to the figures with more light and detail on the top of the green shirt (that happened to be worn by my son Joe), the back of their heads, the top of the pink shirt, which I decided to make authentic by painting it stripes and all, just as it appeared in the reference photograph.

Then I highlighted the back of the green shirt, the uppermost crinkle on the white pants, and the back of the legs.

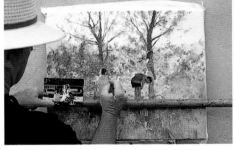

With steady hand I applied highlights to the girl sitting on the bank.

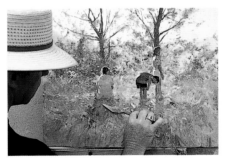

Then I went back with the painting knife to finish off the picture.

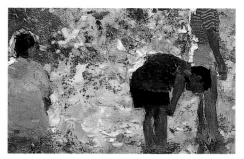

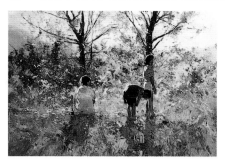

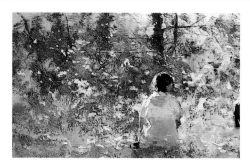

My dominant command post was the three figures. They were holding the light just right, up to the highest value. It was time to attend to all the secondary posts.

I moved between clean colour pulses and highlight pulses or "clicks" as I like to call them.

This halo of light was exactly the effect I was after having spotted the trees on that early morning.

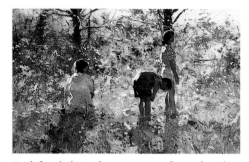

Look for clicks in the trees, pops of straight colour — virtually yellow, with clicks of straight white on the edge, clicks of light groups bunching around a cluster of leaves, sprays of clicks along a branch, drops of light in the foreground and a pop here and there in the shadows cast by the figures and the trees.

All these touches were strategically placed to reinforce the feel of light, light and more light.

Even the contrast of my signature serves to enhance the light!

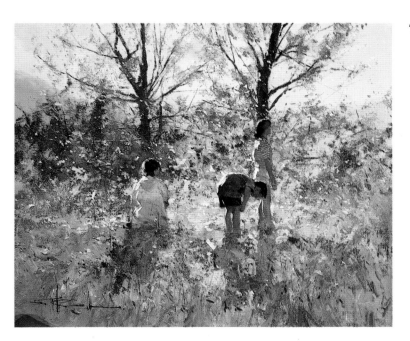

"Hazy Morning" Oil on canvas 24 x 20"

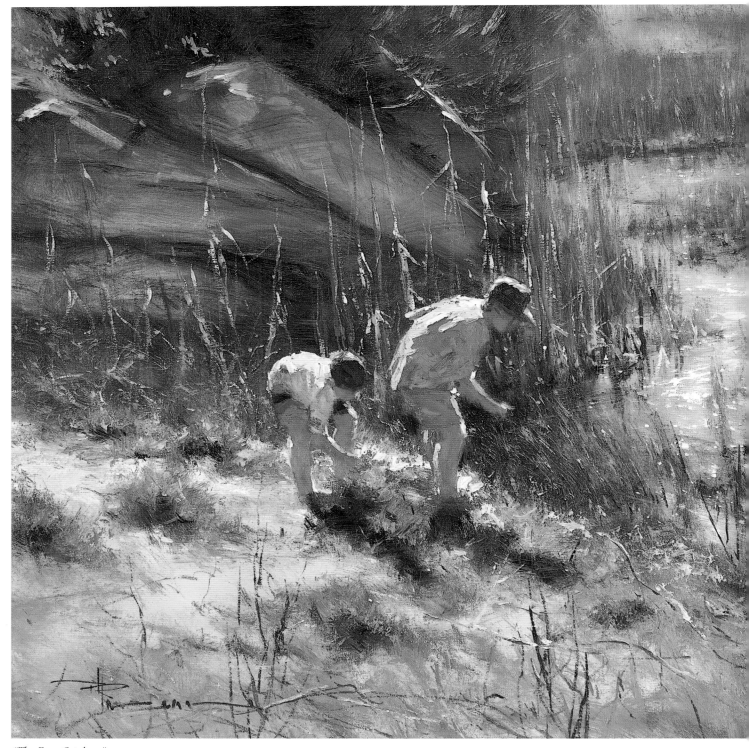

"The Frog Catchers"

"Strong colours and their close association with each other provide impact and serve as a magnet to the viewer's eye."

COMING TO GRIPS WITH FOREGROUND DETAIL

"The Frog Catchers"

The closer things are to us the more detail is needed. What we must be wary of, however, is going too far! This scene was chock-a-block full of intrigue, both for the artist and for the two boys, as they were totally intent on catching some frogs!

The boys are mine, Joe, aged 10, and Graeme, the younger aged 8. We were on an outing near a place called Alpine, and the small stream was swollen with some recent heavy rains, so the boys felt this was the best time to hunt. I was trailing and stalking them with my camera as they stalked the illusive miniature green frogs. As we wended our way along the bank I experimented with the framing of the scene in front of me using the camera's viewfinder until I hit the composition that I decided to paint.

I asked myself, what have I got to make a painting from? Hey, a lot of tremendous stuff — mid-day light, rocks, reeds, watergrass, spiky branches, sandy patches, lush green grass and two adventurous boys!

I was excited by all these elements and looked forward to getting stuck into this painting. I wanted to paint as much of the scene as possible to preserve the integrity of the moment.

The Step-by-Step Demonstration

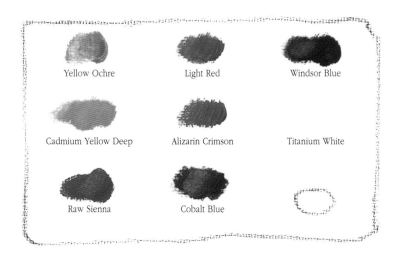

The Colour Palette Used in this Painting

Yellow Ochre Light Red Windsor Blue

Cadmium Yellow Deep Alizarin Crimson Titanium White

Raw Sienna Cobalt Blue

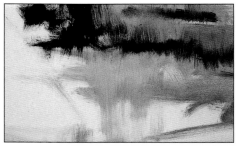 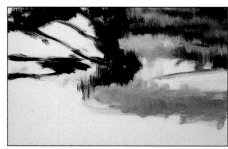 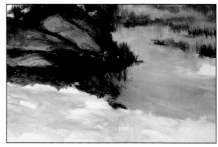

I decided to work from background to fore-ground, from top to bottom.

A thin wash was applied to the defining blocks of water, reeds and rocks. The colours used were Cobalt Blue, Windsor Blue, Yellow Ochre, Raw Sienna, Light Red and Alizarin. My white was Titanium.

Although the sky was out of the picture in this composition, it was not out of mind, as it acted as a unifying agent by infusing its blue into everything.

I really don't know what I would do without my faithful 1" hardware brush. As you can see I used it to its full advantage on every painting in this book.

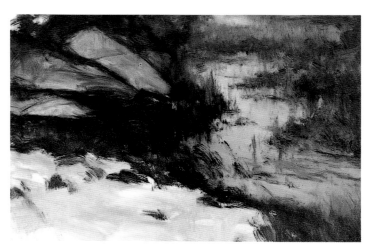

I advanced further to the bottom of the scene. As an artist my stance is vertical to the canvas, with good body balance.

It is extremely important not to adopt a lazy posture or indeed a lazy mind, as although looseness is the order of the day, this comes from light brush control, not from light mental control.

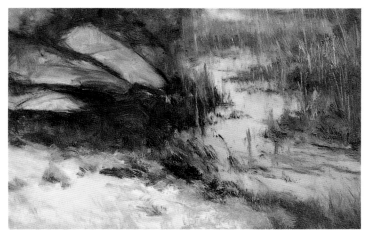

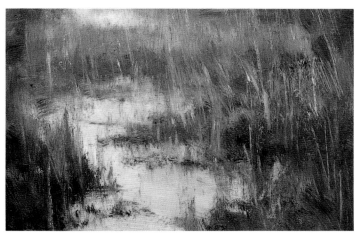

I attribute part of this looseness to the straggly nature of the abovementioned brush. Often I deliberately work to destroy the manufactured form of a brush to fit the effect desired.

I loaded the brush with paint and skipped onto the surface with a vertical movements. I always try to follow the directions as nature presents herself.

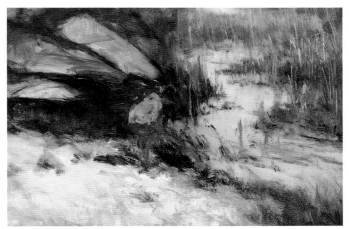

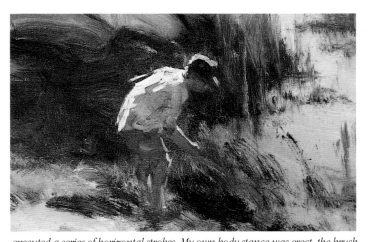

Without any more ado on the setting, I went straight into the figures. It is extremely important to maintain the flow of a painting and advance the excitement by not resting. Make the decision and get into it! Painting the figures is no different to painting the rocks or any other shape. Shapes are shapes. I positioned Joe where I felt his presence gave more dramatic impact. I still had to place the figure of Graeme, and I kept this in mind. I used a flat bristle No. 6 brush and

executed a series of horizontal strokes. My own body stance was erect, the brush held very gently between forefinger and thumb. Paint was applied without medium.

Once the shaded body areas were roughed in, I went directly to the highlights. This not only "confirmed" the shape, but gave me the command post from which I ordered off the relative importance of the rest of the painting. It was from this that all the other parts were given their relative importance.

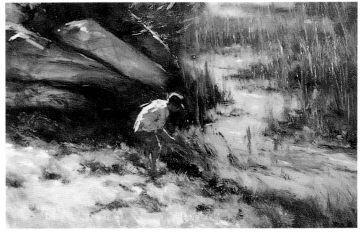

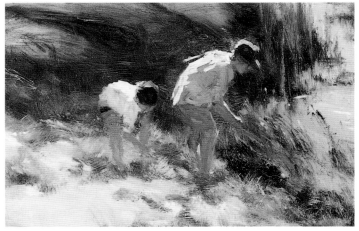

Many theories have come from what to do at this part of a painting, mine may not be as academic as some others, but it does work, and it's home grown and time tested!

Then I advanced to the second figure, Graeme. By this stage I had not had a break from this painting, to do so would be to lose my gathering rhythm and spontaneity. The stronger colours and their close association with each other provide impact and serve as a magnet to the viewer's eye. Highlights drive this home. Bang on the light on the top of the second figure, and POW! out this one popped.

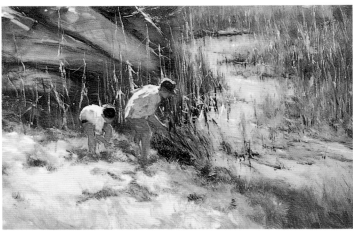

Now I had all the components in and it looked pretty good. The equation was set. Nice balance, good potential for lead-ins and a basically sound composition. Figure size was right, it looked and felt natural, not stuck on.

The reeds were also starting to look pretty convincing.

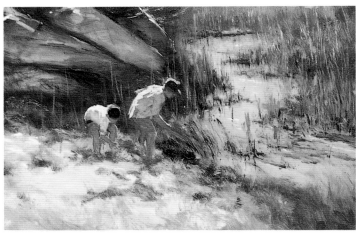

I worked in the area behind the boys and painted in the dried-off stems and leaves of the reeds. This, too, pops out against the darker backdrop of the shaded rocks. The boys' setting looked great. I walked back three to four steps for the two-hundredth time, had a look with one eye and with a mental nod of approval, took my first break. I went away to water the garden.

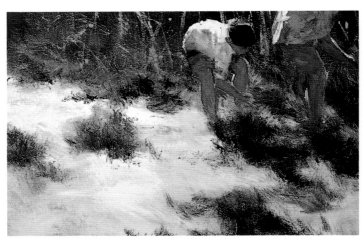

My next step was to anchor the two boys and stop them from appearing as if they were floating! I did this by painting in their shadows.

I took this line further by going into the tufts of grass. I went back into the water again looking to firm up the grass stalks and reed stems. I clipped strokes of yellow and light golden green throughout and about the watery vegetation. The surface of the water was dabbed with alternate brushstrokes of light pastelly-blue and cream to make it glitter and shimmer and move. The surface pattern was done in a way to lead the eye off from the boys and out of the painting. I used my brush on its edge loaded with straight paint and applied with one deliberate smooth action, although various angles were used to try to repeat the shapes and forms of the various plants as they adapted to their own particular circumstances.

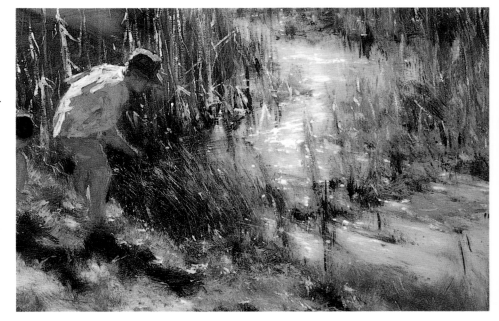

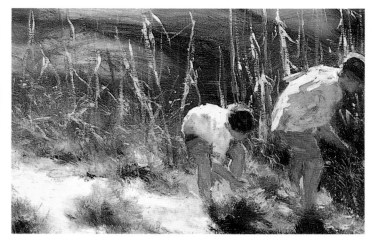

I was rapidly approaching the end of this piece. I continued to advance and retreat from the painting as I looked to key in and bring into tighter association all the elements around the two boys.

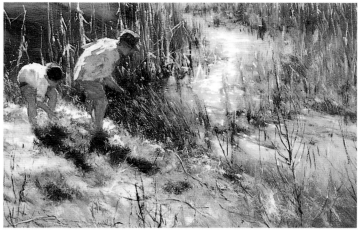

I hit the highlights on Joe's cap, their backs, legs and arms to lift their claim in the painting, and stamp the message in the piece. Then I was into isolated spots of white, clicking here and there to really "turbo" the light. At the same time, I headed down the value scale and picked up a load of Alizarin/Blue mix to hit a dark spot that needed a bit of livening up. To make light perform its magic in a painting it has to be predicated with its opposite. That was about it! Looked pretty good both close up and at the mandatory ten feet! Time for a beer! G'day, see you next time!

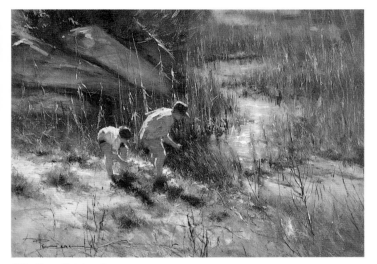

"The Frog Catchers"

Focus On The Foreground

For some reason many aspiring artists run into bottlenecks when they deal with foregrounds.

I believe the essence of any painting, and any part of a painting, is spontaneity, but with attention to detail. In real life, the closer things are to us, the more detail we see. This is also the case in painting. What we must be wary of, however, is going too far!

Up to the point where the two boys were put in, detail in the demonstration painting was minimal, and wherever it did occur, it was either broad in scope or the result of what was left by the shape and loading of the large brush. Detail was a by-product.

The time to detail started when I introduced the boys, as you will see on the accompanying pages. There was a deliberate, intended effort of shaping and sculpting. Once this was started the swing of the painting went from broad style to detail style painting. Detail in the grass at the boys' feet was keyed from the extent of detail in their figures. The brown reeds behind the boys and the grass stalks in the water got their presence and detail after the figures of the boys. The foreground was treated in the same fashion. Although it contained more detail I didn't overdo the foreground because I didn't want to overpower the presence of the figures.

When I talk about detail, I refer to both value extremes (light and dark) as well as colour variety (hue) — or a mixture of both.

To effect detail I used a fine brush or a knife. Generally, a combination of both.

DRIVE LIGHT AGAINST DARK TO CREATE A MOMENT OF DRAMA

"The Outlaw"

Contrast is another great tool at your disposal. By playing off light against dark you can bring certain elements sharply into focus and give them more prominence in the storyline.

This is a great story — I think there's a bit of "cowboy" in all of us, and this picture says it all.

I am fortunate to have two great cowboy mates in America; Max and Gary. Gary also doubles up as a 7th degree martial arts black belt, which provides me a little security when I walk dark places with him in the lost evening hours.

Anyhow, many of my cowboy paintings (or in Aussie parlance "Outback paintings") are anchored around the horsemanship and knowledge of these two guys. Max contributes greatly with a lifetime of horsemanship backgrounded in rugged experience of cattle ranching in Montana.

I think the sheer competence of both horse and rider in dealing with this "outlaw steer" came through.

"The Outlaw"

"In a painting everything is part of everything else."

Reference Sketches

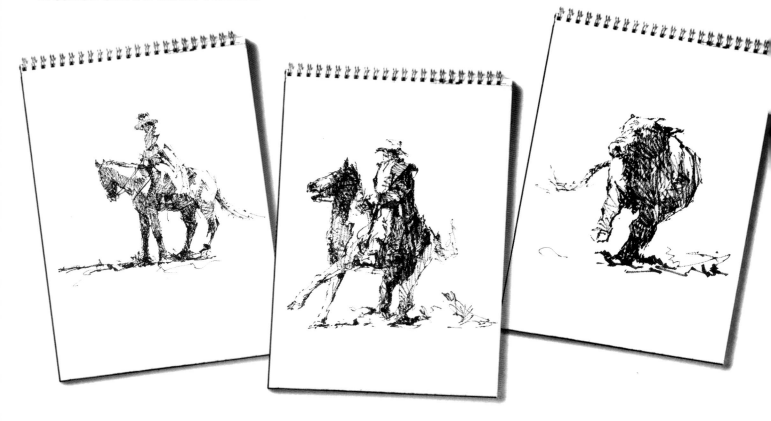

The Step-by-Step Demonstration

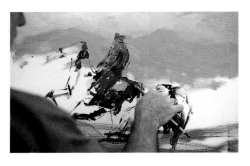

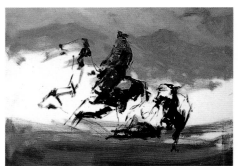

With a Cobalt Blue and Light Red mix and a touch of white I laid in the background hills. Lightening this a little, I roughed in the sky, off-setting the blue/gray with Naples Yellow and white. To create excitement, the sky must have a temperature shift — as we discussed in the previous chapter. The foreground area of Light Red/Yellow Ochre was struck in with a value similar to that of the hills.

Now to the cowboy, and the props that collectively go to make up the story. I had sketched the shape at least 20 times first, so the ease with which this figure apparently flowed off the brush is deceptive, because it had its roots in a lot of effort!

With my No. 2 bristle brush I blocked in the main darks using a mix of Alizarin and Cobalt Blue.

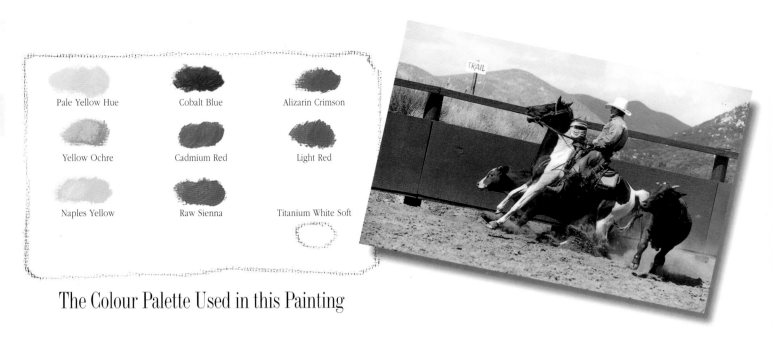

Pale Yellow Hue	Cobalt Blue	Alizarin Crimson
Yellow Ochre	Cadmium Red	Light Red
Naples Yellow	Raw Sienna	Titanium White Soft

The Colour Palette Used in this Painting

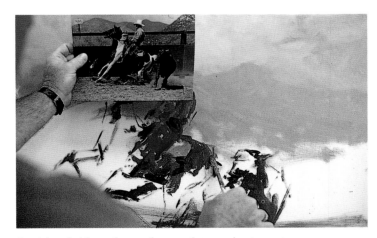

Don't be afraid to refer to reference photographs at any stage.

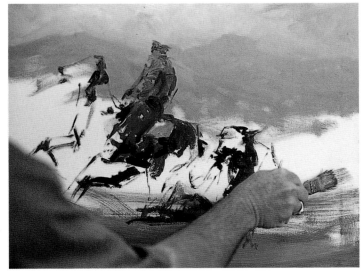

Again, my preliminary sketches of cattle helped me when it came to blocking in the first steer.

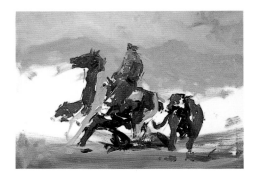

When I put in the second animal I checked to see I had the composition right. The dynamic of the cowboy, horse and charging cattle looked good.

It's all very subtle and low key at this stage — nothing jumps out at you.

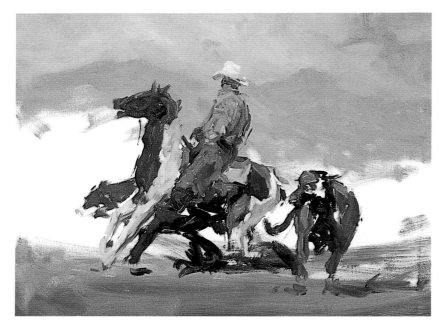

So far, so good. The storyline was well and truly established. The easy competence of the rider, working in tandem with an experienced cow-pony, and the usual unco-operative steers who will shortly find out who is master.

The smaller block colours of the horse were attended to, particularly the lights of the coat.

Here you can see the advances in blocking.

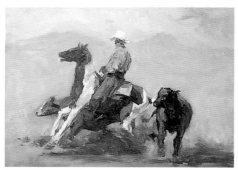

At this stage I was concerned about keeping the impetus going and not falling prey to details.

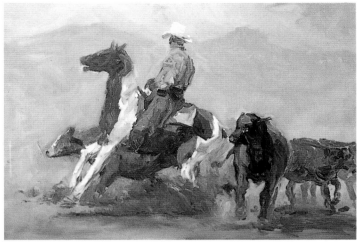

I worked from the horse to the cowboy to the cattle. I studied my command post and decided the cow on the right seemed to hang out too much. I needed to give the viewer's eye a lead-out so I added some more cattle — even though they weren't in my reference photograph. This is where the artist's own intuition comes into play. More cattle — more story.

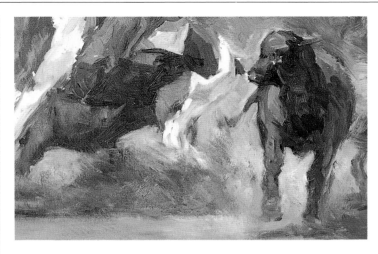

A little bit of attention with my scrubbed up brush created some nice activity around the hooves.

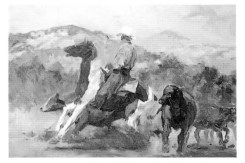

Time to evaluate. I decided if I didn't get back to the background soon I would lose the relationships of the ingredients. I worked over the hills by bringing up the detail in the background.

Everything is part of everything else in a painting — this is "bleeding" as mentioned previously in the piece about inherited colours at the beginning of the book!

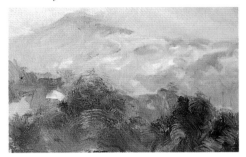

Back to the setting!

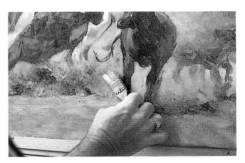

Then I added more detail in the dust using both brush and knife. I was making decisions about balance and relative weight. How far should I bring out the outlaw steer? How much should I "bed" down the rear legs of the propping horse? So I played around with these elements looking to get the right "feel". I worked all my instruments. I began to fill in the context and surrounded and tied in the main objects to the rest of the piece. Here's my faithful brush in action again.

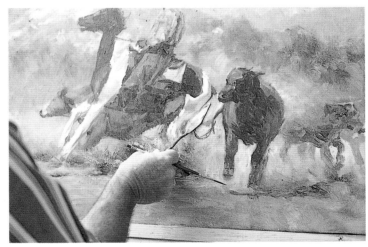

Some shaping with the painting knife helped delineate the form of the horse's rump.

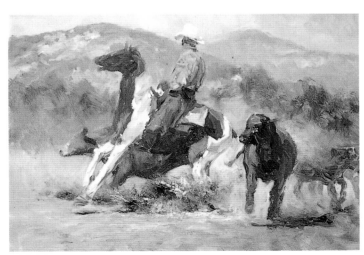

Yes, I was happy with it, but there was no time to rest.

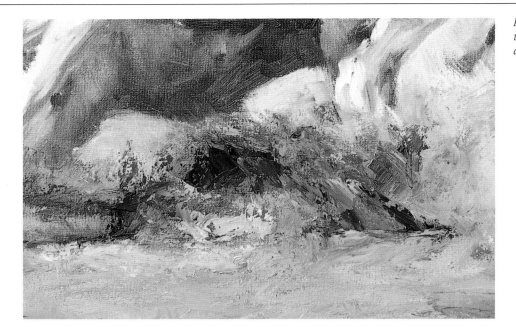

I attended to a bit of detail in the dust and the unsettled earth under the hooves of the horse and cattle.

This "anchoring" as I call it, sets figures down and puts a stop to the sense of floating that often accompanies figures in paintings of this nature. Again, it is important to make your figures sit in, rather than sit on the canvas.

I was back to detail. As one part of the painting advanced other parts, although stationary, appeared to retreat. So I moved back and forth playing "catch up" with various parts of the painting. I worked on the shadow of rider's face, and the horse's halter.

My palette fluctuated around the Light Red, Yellow Ochre, Pale Yellow, Alizarin and Cobalt Blue. The mother of it all though, was still the grey from Light Red and Cobalt Blue.

Here I darkened the shadow cast by the steer's ears.

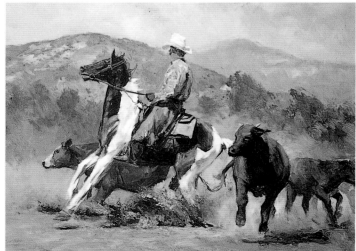

My efforts were devoted to further darkening the darks and lightening the lights. Once the basic composition was made and the players put in place it was then a matter of bringing them all to the stage at the same time for their performance!

I isolated and established the importance of the charging steer by "dusting up" its surrounds.

More fine tuning. This horse was a beauty.

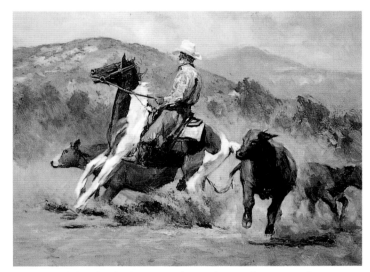

Guess which brush I used to create this explosion of texture and excitement!

This stage confirms my push to refinement.

Then I added some foreground detail.

What was needed next were some small touches to reinforce movement and confirm shapes.

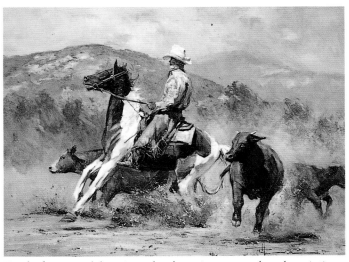

For the foreground there is rarely a better instrument than the painting knife. I used it to "drop" on a blob of stationary or lifting dirt, and "drive" light against a dark to create a moment of drama — this is the contrast that isolates certain sections of a painting.

Here's the resolution to the wayward steer in the background. Notice those eyeballs, the detail on the stirrup and chaps, and that lovely play of light against dark.

Eyeballs on this runaway portray him as the cantankerous animal he was.

Calm competence at work. Highlights and shade, definition and suggestion all working well.

Finally I had achieved what I had set out to do — the "outlaw cow" on the run! Not a bad painting!

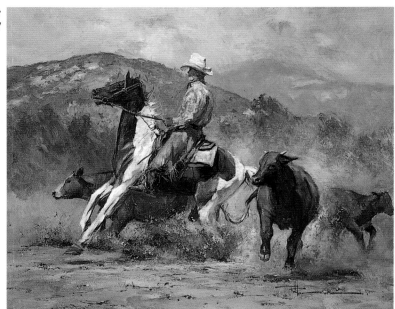

How To Paint Cowboys

Before you do anything, sketch the figure at least 20 times.

My palette is from top right to bottom left:

Alizarin Crimson
Light Red
Cobalt Blue
Yellow Ochre
Cadmium Red
Titanium White Soft

As always, look to the grey as a starting point.

With this grey rough in the head and the fore section of the horse.

Grab a bit of Alizarin and block in the shirt of the rider.

This is joined by a touch of the mix from Cadmium Red/Yellow Ochre.

With a bit of the grey from Light Red/Cobalt Blue darken the appropriate areas of the shirt.

Use this to shape the arm.

Then create shadows cast by the head and hat.

With Light Red and Yellow Ochre block in the legs and chaps.

Paint the front of the saddle with a mix of the above but add a blend of Yellow Ochre and Cadmium Red.

Now go back to our starting dark, that is, Light Red and Cobalt Blue, and attend to the dark skin areas of the horse.

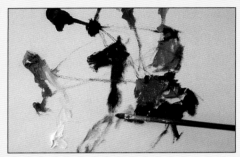

Paint its chest, its rear and underbelly.

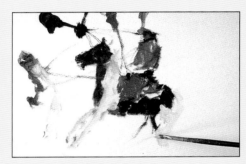

With a mix of Yellow Ochre and white block in the lights of the horse.

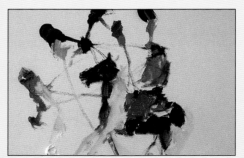

Follow my diagram and take a bit of white to the mother grey (Light Red/Cobalt Blue).

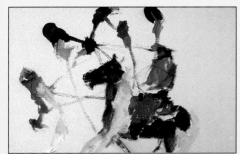

We get a blue/grey mix to shape up the shadowed areas of the forward and back legs.

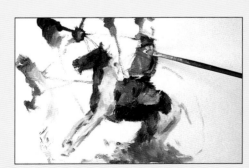

Highlights! At last we can pull out the lights. Before you do anything "anchor" the horse. That is "sit" him into the setting by putting a shadow and rising dust under him.

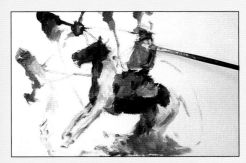

Now take a mix of white with Alizarin and highlight the cowboy's shirt.

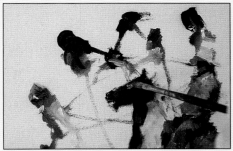

Taking a bit of white go back to your mother grey and mix a bluish grey (on the light side) and work over the browns on the horse's head to further lend it shape.

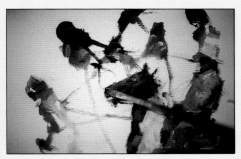

Do the same with the nostrils.

Repeat for the horse's forehead.

Take a mix of Yellow Ochre and white, and fashion in the shape of the hat.

Continue by adding white to the "bedded" colour and work over the dust. Highlight the chaps.

Then highlight the denims, the saddle, hat, horse's tail and so on.

Keep going until there is a uniformity of life about the painting.

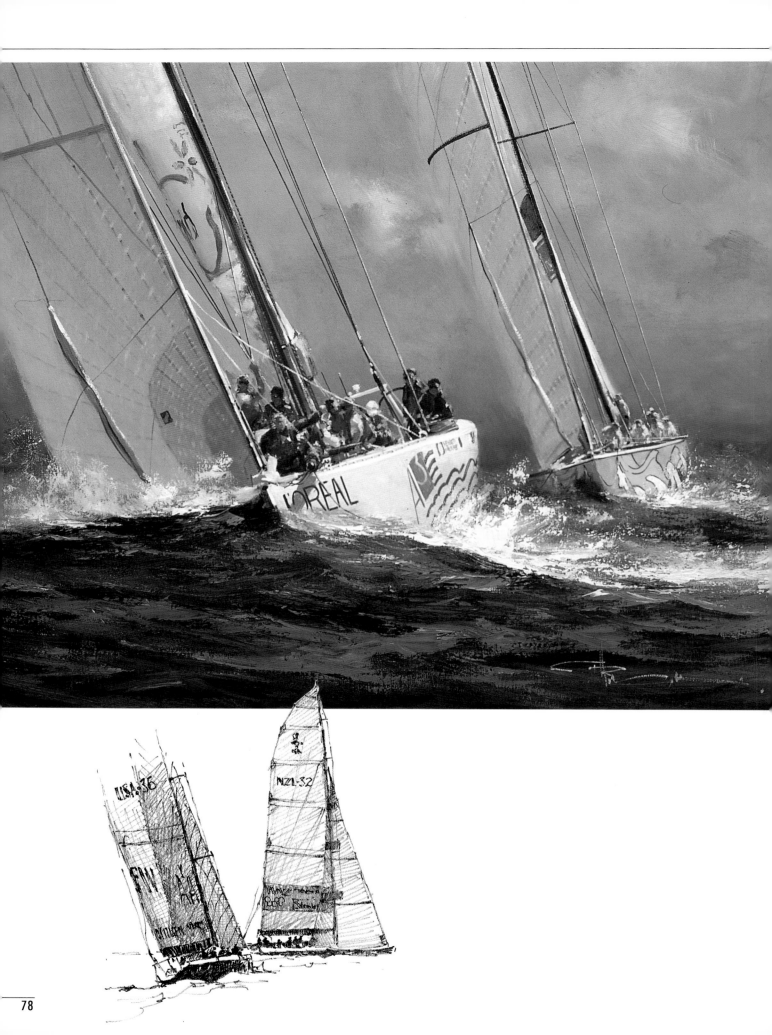

KNOW HOW TO WORK THE TEMPERATURE SCALE

"The Women's Team for the 1995 America's Cup"

The high drama of international yacht racing is a good enough subject in itself, but any painting can benefit from working the temperature scale. If you hop from warm clumps to cool spaces you will subliminally excite the viewer. So that's what I did here, and it paid off, because this painting assisted me in being awarded the International America's Cup Artist Medal for the XXIX America's Cup held off San Diego, USA, in May 1995.

Bill Koch, the successful defender of the 1992 America's Cup, put together the first All-Woman Team to compete in the 136 year old America's Cup. It was known as the "America 3 Women's Team" and they smashed a 136 year old tradition of male-only crews. For me they were the best!

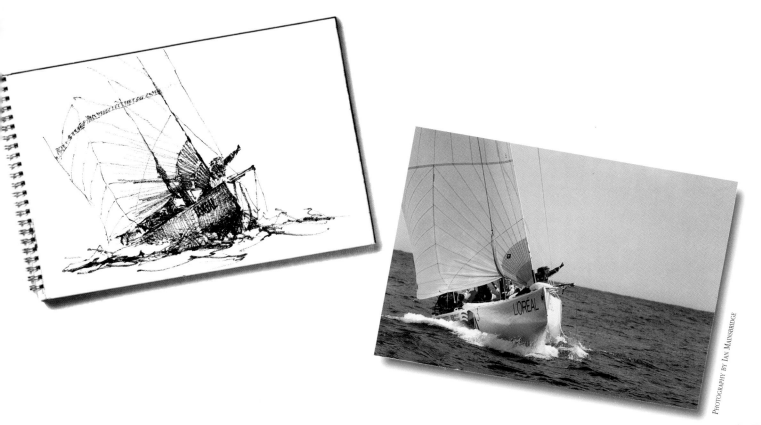

PHOTOGRAPHY BY IAN MAINSBRIDGE

The Step-by-Step Demonstration

The Colour Palette Used in this Painting

Yellow Ochre · Phthalo Blue · Alizarin Crimson

Raw Sienna · Ultramarine Blue · Titanium White Soft

Cadmium Yellow Deep · Windsor Blue

Cobalt Blue · Cadmium Red

I sketched in the two yachts with a well worn brush using thinner medium and Raw Sienna, but you can use any colour that is fairly neutral in value.

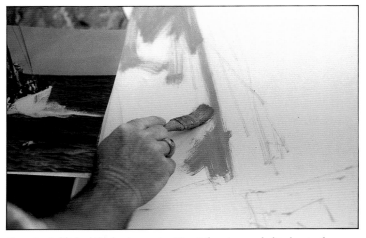

Once I established the basic composition I then proceeded to lay in the main block areas with my 1" wide hardware standard bristle brush. I began with the dominant sail area.

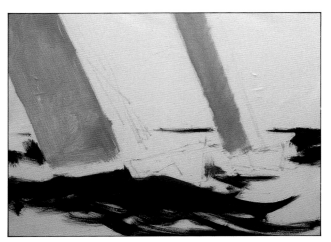

This is the colour (Yellow Ochre and Raw Sienna) from which I keyed in the supporting sky and water.

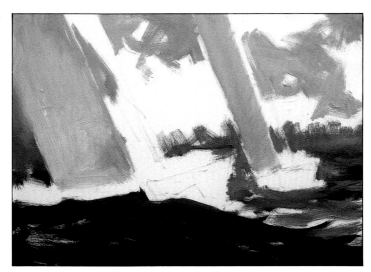

The sky colour was a mix of Windsor Blue and Alizarin Crimson with a smidgen of Raw Sienna and Yellow Ochre. As I approached the horizon I greyed out this colour.

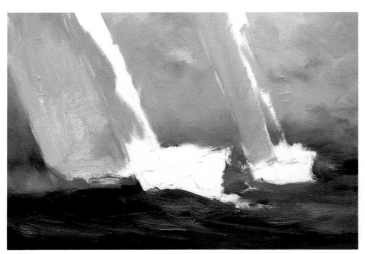

This is what I mean by temperature contrast. Higher in the sky I established some temperature contrast by hopping from warm clumps (yellow) to cool spaces (blues). It is essential to work the temperature scale as it subliminally excites the viewer.

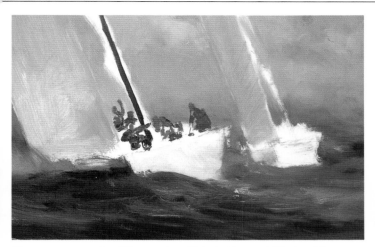

The water was a mix of Ultramarine, Phthalo Blue and Windsor Blue with Alizarin. Again I sneaked in the warming temperature effect of a red (Alizarin). Following the rules of reflection, the water area below the forward sail inherited the yellow.

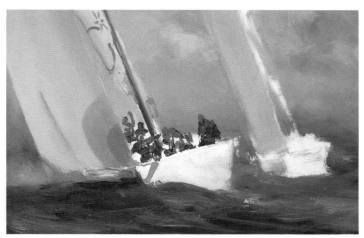

I sculpted the blocking-in around the two previously sketched in hull shapes. This would serve to confirm the composition, or cause me to alter it. So far it looked fine!

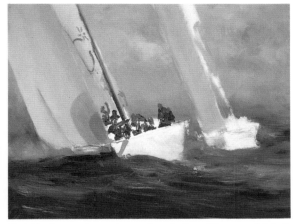

Quickly, I moved to animate. I worked rapidly to establish the body shapes of the women working the deck. Wearing "America 3" colours of blue and red the shapes were beautifully emboldened. Along with the juxtaposed active positions of the women, this area of the painting would be a later target for detail and attention. I darted from Cadmium Red to Cobalt Blue and blocked-in these small but important shapes.

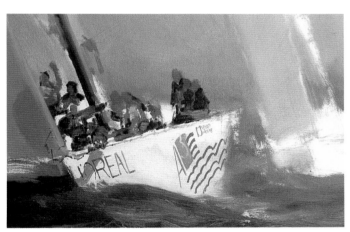

Then to the hull. Another area for detail. Both these sloops had fabulous hull designs with the forward yacht sporting a graphic of the stripes of the national flag.

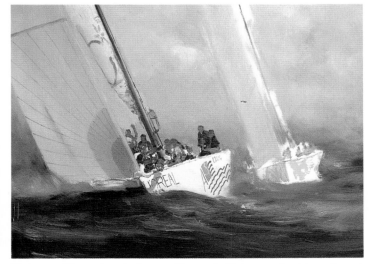

To the rear "Young America" was emblazoned with loops and swirls configured to represent a mermaid. What fantastic support material for a painting! I rapidly applied a suggestion of these shapes onto the blank hulls.

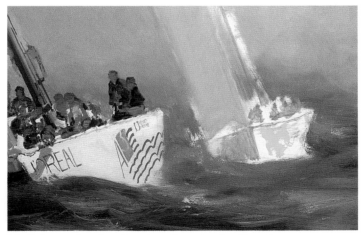

I fluffed some sky colour into the sails to give the effect of transparency. (These are carbon fibre and veil thin, and so they absorb the colour of the background).

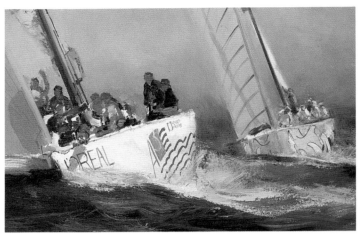

The second hull found resolution. I went back into the water. I loaded up the edge of my wide brush with a blue/white mix and hit the water area where it was broken by the surging bow of the hull.

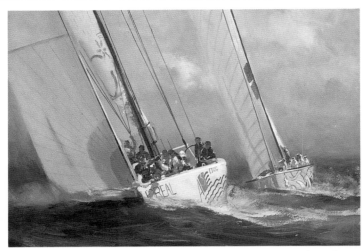

The water to the left in shadow was given a bluish tinge, but to the right where sunlight existed I went back in with a creamy white to lift it into a sunlit spray.

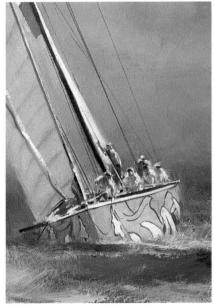

The undulations in the water as it peeled away from the bow gave me a chance to add rhythm, movement and excitement to the painting. It was really beginning to hot up!

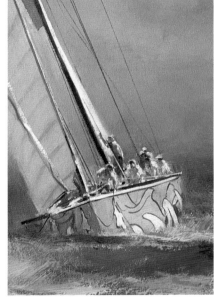

The illusions of detail but not really!

I looked to "body up" the sails by suggesting the ribbing in the material. Sail signage also came in for some attention.

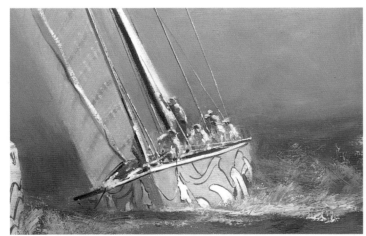

All these yachts had major corporate sponsors who contributed millions of dollars to the campaigns and I felt it appropriate to have their logos decorating the sails. Some yachts were stock standard, others were done with imagination and flair, especially the Spanish entry!

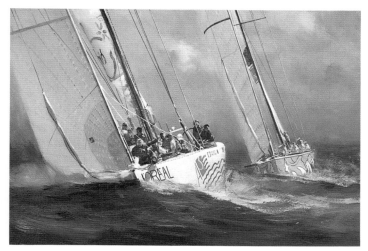

I personally liked the symbolic sunflower on the women's sail as it contributed excitement in both colour and design!

No resting now! Still looking to detail, I headed for the rigging. The stays were located, and what a wonderful opportunity these provided to the artist. They unified the sails and the bodies of these marvellous titans of the sea. I used the cardboard core of a roll of canvas to guide the hand and brush as I sought straight thin brushstrokes. This was only the second time I thinned the paint. The first was when I initially sketched in the two hulls.

It's almost impossible to effect thin lines without a hand support. As you can see, my rest makes this painstaking job a little easier.

Then it was back to the water with my painting knife.

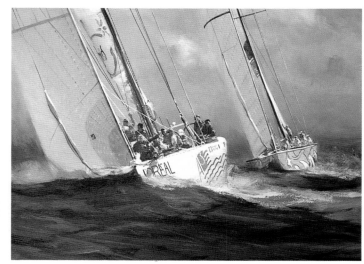

Look at the reflected sail colour in the water.

Let's see where we are!

I wanted to "click" the light where the sun played and give a shot of clear colour. In fact, I pushed the effect of sun on colour beyond the "real" to drive home the action and colour.

The water was absolutely coming to life. Feel wet yet?

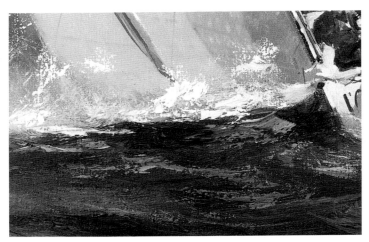

Splash! Some reflection from the sail, again pushed to the limits of reality.

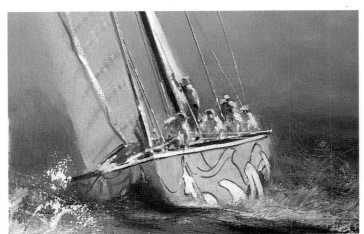

I retreated to address the same components in the trailing boat. I used a camel hair No 3 brush for the fine work.

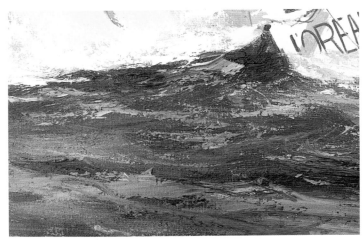

I happily reached for the painting knife. Now I was really going to liven this piece up! I was not interested in going anywhere but the water. I spent a lot of time and burnt out my patience doing the detail! Now it was time to crank up the sea.

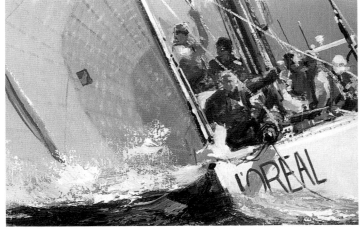

I darkened the darks, first going to the left side of the hull, which was the darkest spot of all. I hit that with Alizarin/Phthalo Blue. Next I loaded up with alternatively blue/white and yellow/white and worked into the foam area I had previously attacked. This time I looked to "skip" the paint in to give the effect of spray. I then moved forward and rendered a steely blue to the water to establish smooth spots. The colour was close, but a step down the scale from that of the sky. Hey, that's all! Simple wasn't it!

How I Painted the Crew

The crew consisted of a number of human body shapes, some overlapping and some in isolation, some active some still. They were all sporting the colours of the "America 3" syndicate, that is, full sailing jackets in blue with red trim, as well as half jackets, again in blue but showing white sleeves from the undershirt. Some of the girls were wearing sunglasses and some even wore lovely yellow sunflowers in their hair! They were all suntanned, with hair being either blond or brown. (The artist must be studious and patient with these details. It is not something to be rushed.)

Initially, I broadly positioned the shapes with a No. 6 flat bristle brush using the photographs as a guide. I sketched the shapes a few times on a scrap of paper in order to become familiar with them. I was fortunate to have a source for this essential detail in the form of photographs which I took on the water from another yacht — which was a very uncomfortable trip and I warned the skipper beforehand that I would probably be sick all over his deck. However, I always take my own shots, because that way I get the "feel" for the conditions and circumstances in front of the lens.

When I returned to finish this area of the painting I used a long-haired sable No. 3 brush. I went into the broad shapes with a very fluid mix of paint and thinner and reshaped and coloured-in where desired. I let this dry off — only a matter of a few minutes because of the thinner. With the same brush, but with the bristles shaped into a small wedge by sliding it between my forefinger and thumb, I carefully loaded the tip with straight paint, and with one stroke I laid the point of the brush onto the area needed. This is my highlighting technique. I'll frequently use a rod or stick to rest and steady my arm, especially if the stroke is continuous. As a general rule however I work freehand, as this has more of a spontaneous effect. I worked the hair highlights, the glint of the sun on the edge of the sunglass frames, the clink of light on the sleeves and shoulders of the jackets, the flesh pink on the hands, arms and side of the faces and so on — wherever the sun performed its magic.

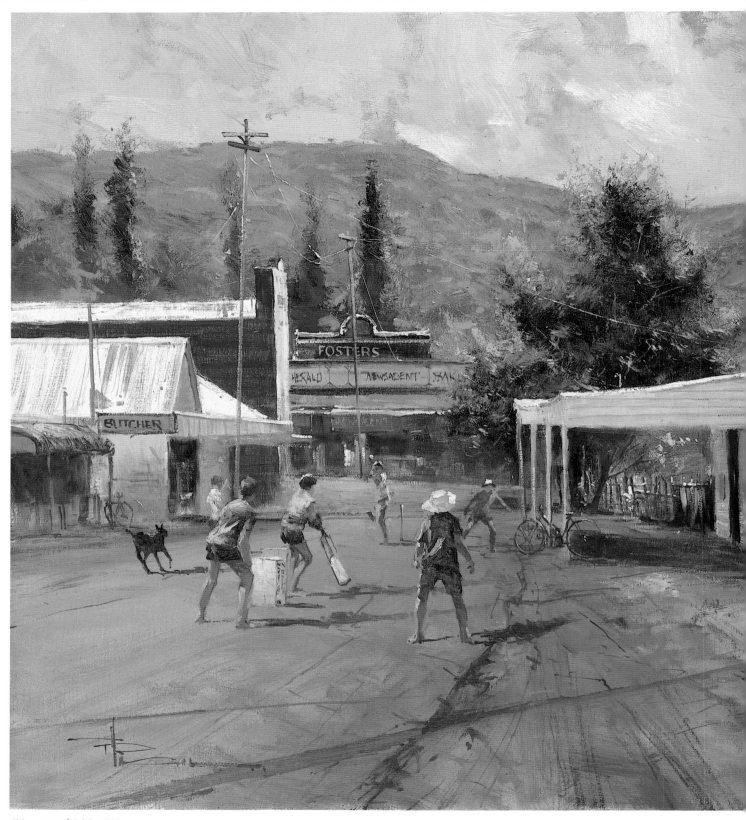

"Murrurundi" 24 x 30"

"Where you place your first command figure is crucial"

MAKE YOUR PAINTINGS VIEWER-FRIENDLY

"Murrurundi"

Here's where we get test ourselves on what we have learned so far about command areas, lead-ins and lead-outs. This is a complex painting, chock-full of elements all carefully placed and painted to accomplish an overall storyline about life in a country town.

On the way to Tamworth crouched at the base of the Great Dividing Range, sits the sleepy town of Murrurundi. It is absolutely typical of Australia. Its reason for existence is that roads, rail and the Hunter River converge there; a dynamic combination for a settlement. The place is hot in summer and cold in winter — and the locals have a well developed thirst for beer.

The scene I decided to paint was off the main through-road, up one of the not so many side streets. The pub that sits at the end of my side road looks onto the railroad that passes by its other side.

You may want to refer to the section on command areas at the front of this book, where this painting is specifically mentioned. Here goes!

The Sketches and Reference Photographs

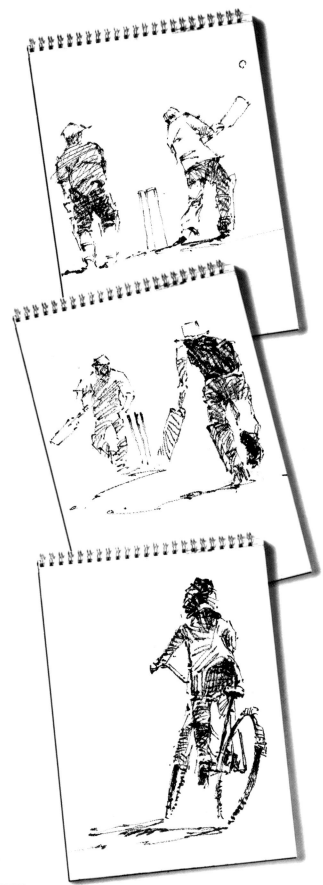

The Step-by-Step Demonstration

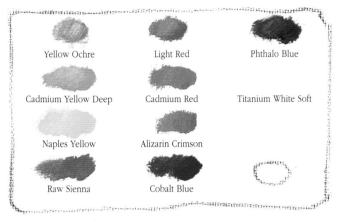

The Colour Palette Used in this Painting

Yellow Ochre Light Red Phthalo Blue

Cadmium Yellow Deep Cadmium Red Titanium White Soft

Naples Yellow Alizarin Crimson

Raw Sienna Cobalt Blue

I sketched in the rough positions of the buildings with a neutral grey/brown. I decided to accentuate the long overhang of the shop on the right to give me a nice yellow balance for the grey/blue hills that would make up the background.

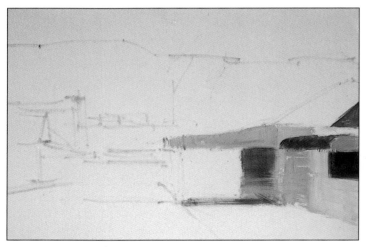

I used my 1" hardware brush to block in the main areas.

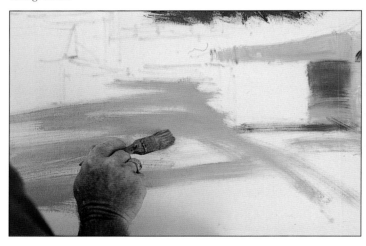

I made a grey base for the earth of the street, and applied it liberally.

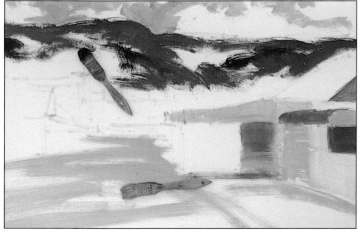

For the hills I mixed Cobalt Blue with Light Red and a touch of Raw Sienna and white. The sky was the same, but of a higher value. Both areas had the grey base (Light Red, Cobalt Blue).

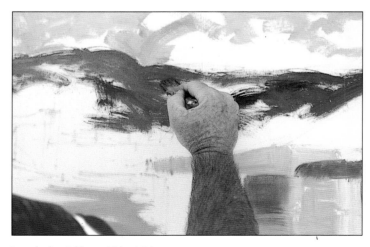

I worked quickly and I kept it loose.

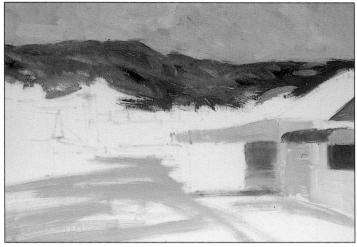

The general store and awning in the foreground were made using Yellow Ochre, Raw Sienna, Light Red with a bit of Cobalt Blue.

I love my hardware brush! This is what oil painting is all about.

The trees blocked in behind the buildings served to accentuate the shape of the buildings in the distance and in the foreground.

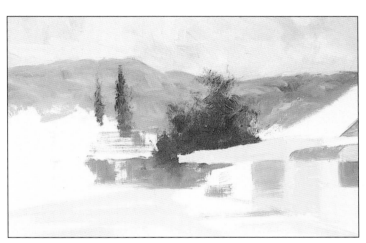

I suggested a bit of detail in the pub at the end of the street.

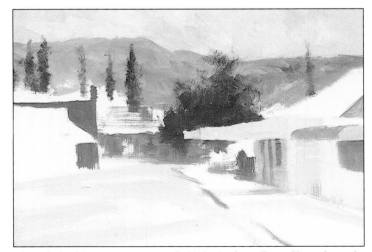

These darks (Alizarin Crimson, Cobalt Blue/Light Red) quickly push out the lights. My reference photo has this effect but not to the degree I created here. I picked out the large building on the left with a greyed mix of Alizarin. Some Titanium White added to this mix was used for the shadows on the pub and for the foreground window.

You can see the brushmarks made by my splayed brush clearly here. Although I worked spontaneously, throwing my brush around, my colours remained pure. I moved back into the sky to create a bit more temperature variation, and make a link with the colours of the building (cream) and shadows (blues). I introduced a "smidgen" of grey tinted with the darks of the trees in the underbelly and leeward sides of the clouds to complete the tie-in.

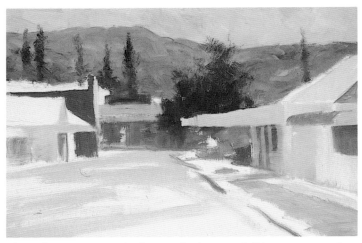

There's been quite some development by this stage. I did some more work on the background and trees, interspersing a mix of mauve tinted Raw Sienna for the tree clad hill while mixing a deep, dark green for the tree just behind the buildings. This deep dark green was a mix of Phthalo Blue, Alizarin and Raw Sienna.

Remember, I wasn't trying to create an architectural drawing, just blocked shapes that are nevertheless an authentic suggestion of the buildings commonly found around Australia. I blocked in a pale, washed-out grass verge.

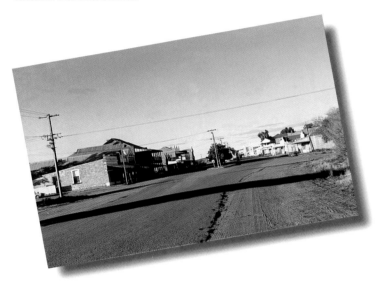

I looked through my references photographs for another street photo with a better earth colour for the street. The photo opposite was taken in Western Australia where dirt is red/orange, in fact, everything is red/orange! This is the effect I wanted here. So I blocked in a mix of Cadmium Red, Light Red, Cadmium Yellow, Yellow Ochre and Alizarin Crimson and laid it on the street.

My immediate next action was to "lift" the trees. I picked up a mix of Yellow Ochre and Raw Sienna and white, and each was individually dabbed on using the edge of my hardware brush. To kick the highlights along even more, I mixed Cadmium Yellow Deep with white, and skipped the colour on with the furled bristles.

Once you do one thing and stand back for a look, the next steps become obvious. It was time to lighten up the dark background hills.

I carried this warm highlight colour across the picture, dabbing here and there to tie the whole thing together.

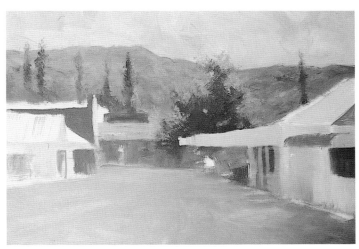

The story so far.

A nice juxtaposition of warm and cool, light and dark and variety in brushwork all kicks the painting along.

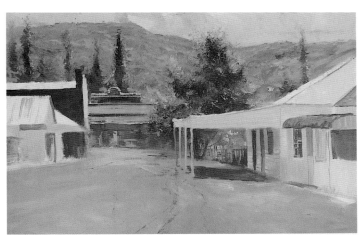

It was time to break into all these warm colours on the road with a mauve-blue. It's a big area, and for it to hold, it needs temperature relief. The paint was applied with the knife as well as the brush. On the dirt road surface I marked some tyre tracks, and run off rivulets. There are some nice lead-ins to the painting. We find our way out of the painting by going up the verticals of the trees and by following the warm cloud puffs in the sky.

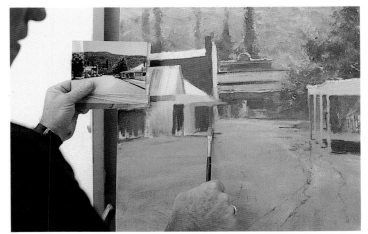

I enhanced the pub and far left building, "built" the sunstruck awning posts and suggested timber planks and corrugated iron using subtle downward strokes.

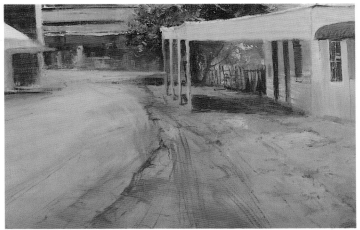

You'll notice in this detail that I buried the tidy grass verge, and conjured up more tracks of mauve to lead the eye into the picture.

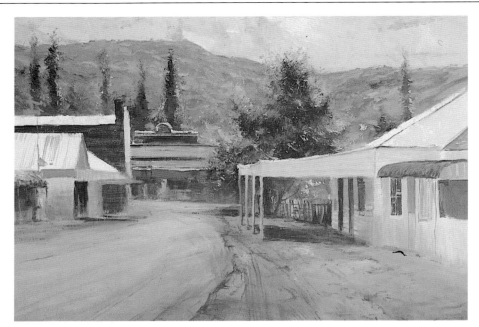

Well it's an authentic backdrop, but now we get stuck into what this painting is all about. Life in a country town.

Country towns always have boys and girls in the streets playing marbles, riding bikes, flying kites and so on. I reckoned a cricket game would do the trick here! If I got it right the placement and proportion of the first player should reinforce the lead-in and amplify the introduction of the eye into the painting.

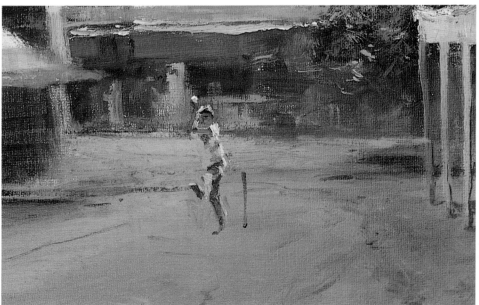

I searched through my photo collection for kids playing cricket, chose one and started painting an energetic right hand fast bowler set midway up the street.

I painted him in, and without hesitation dropped on the highlights.

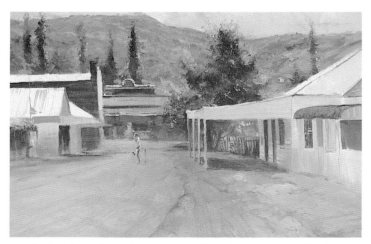

I had a few photos from which to choose, but what made me go for this one was the light clothing and strong colour contrast, that is, red and white. He was fairly distant in the painting and his light attire helped pull him out of the relatively dark background. With the highlights he went "pop"!

I wouldn't need to be so exacting with figures close to me since their size would compensate. But it was very important to set the first figure right. The second figure was a bit easier, but its location was also important.

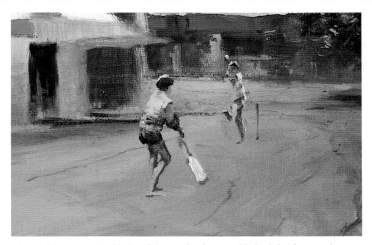

The highlights on the blade of the cricket bat established this boy's role in the painting. His posture is one of readiness. The rest was fairly simple. Remember, these are just SHAPES.

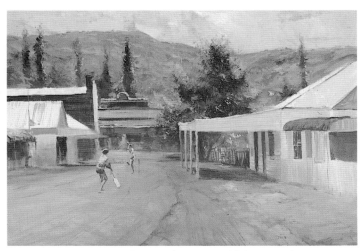

From my command post of the two figures I could then introduce secondary areas.

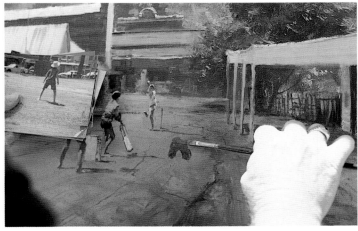

What was needed were some support figures to reinforce the atmosphere of anticipation! My photo collection yielded some great action. I quickly blocked in and highlighted a wicket-keeper, then blocked in an alert looking "slips-fielder" and a smaller "mid-off" figure.

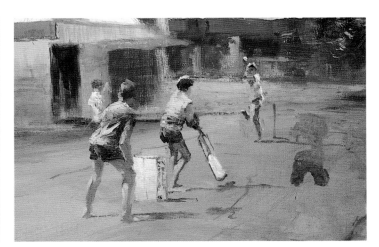

The cardboard box wicket, ground shadows, authentic clothes and highlights all make for compelling and authentic viewing.

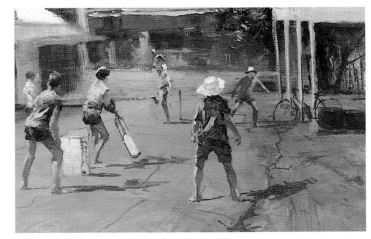

The wicket-keeper, slips fielder, mid-on and mid-off fielders were placed. Look at this action — the scene may be rural Australia, but it could just as well be the Sydney Cricket Ground for its intensity.

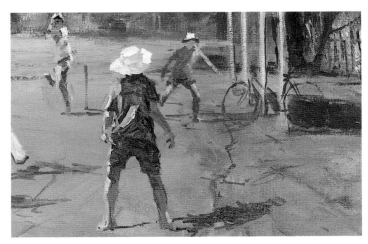

I decided to look to the things that kids have with them, both to add authenticity as well as create interest and detail in the surroundings. Where there are kids there are always bicycles leaning against posts, fences and walls, or simply laying on the ground. Again my reference photos provided some clues.

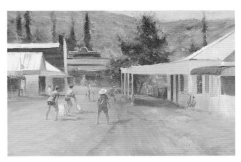

I simply deleted the riders, changed a few angles and in they went.

 Suggesting a bicycle isn't all that difficult really. A few lines, then some important highlights on the bike itself, and also highlight and shadow on the wooden wall, made this a thoroughly convincing bike.

Let's evaluate the scene so far. What else is missing?

I needed to detail the building at the end of the street!

I included the Fosters Lager sign, a suggestion of signwriting, and then a romantic version of a power pole. These towns never really have truly upright power poles. There's always a bit of lean this way or that! I attended to this as well as the power and telephone lines. I used my sable brush with an armrest to help steady my hand. The light on the lines does a great job in busying up the air above the game without distracting.

A second telegraph pole went in and I festooned it with cables. I added a third pole and some associated posts, a downpipe drain and a chimney. Then I cast a shadow right across the street, suggestive of another pole backlit by the sun. The only thing left then was the ubiquitous wandering dog which completed the game scene.

I then went back into all the areas of the painting to tie in the highlights and bring in parts that I felt needed pushing a bit more.

 I did this by adding a click of light or by dropping a heavy dark accent here and there. It was all a case of setting off little spots of detail and interest.

These spots of command were keyed off the predominant command spot — the children playing cricket. Their importance was established by contrast and colour and I took care this area was never closely challenged by colour and contrast elsewhere!